Souvenir of Canada

Douglas Coupland

Douglas & McIntyre
Vancouver/Toronto

Douglas & McIntyre
2323 Quebec Street, Suite 201
Vancouver, British Columbia
V5T 4S7

National Library of Canada Cataloguing in Publication Data
Coupland, Douglas
Souvenir of Canada
ISBN 1-55054-917-0
1. Canada—Social life and customs.
2. Canada—Pictorial works. I. Title.
FC89.C595 2002 971 C2001-911747-7
F1021.2.C68 2002

Design by Jen Eby
Cover photograph by Photo Technic
Printed and bound in Canada by Friesens
Printed on acid-free paper

The publisher gratefully acknowledges the financial support of the Canada Council for the Arts, the British Columbia Ministry of Tourism, Small Business and Culture, and the Government of Canada through the Book Publishing Industry Development Program (BPIDP) for its publishing activities.

Every effort has been made to trace ownership of visual material used in this book. Errors or omissions will be corrected in subsequent editions, provided notification is sent to the publisher.

Credits

adbusters.org: 116
Roberta Bondar: 4/5, 80/81, 128/129, 132, 133
Karin Bubaš: 64, 65, 92, 93, 100, 101, 121, 137, 144
© Camden House Publishing: 32 (caption)
Canada Centre for Remote Sensing, Natural Resources Canada: 32 (photo)
Canada Post/Postes Canada: 50
CP/PHOTO/Peter Bregg: 36
CP/PHOTO/Montreal Star: 34/35, 40
CP/PHOTO/stf: 37
CP/PHOTO/stf-Jacques Boissinot: 120/121
Douglas Coupland: 12/13, 20/21, 28/29, 46/47, 60/61, 72/73, 73, 84/85, 87, 88, 89, 118, 119, 124/125
 Thanks to Ken Mayer for camerawork and lighting.
Dr. Douglas C. T. Coupland: 126/127
Coupland family photo: 131
E. M. Matson Jr. Co.: 45 (Corry's)
Esso/Imperial Oil Ltd.: 9/10, 52
Chris Gergely: 68/69, 76/77, 96/97, 108, 109, 112, 112/113
Golden Books Publishing Co. Inc.: 82
Haskel: 45 (Haskellite)
© Caleb Huntington: 41, 42, 43
IGA: 141
Imperial Tobacco Canada Ltd.: 16, 17 (du Maurier, Player's, Matinée)
JTI-Macdonald: 16, 17 (Export 'A')
Una Knox: 114/115
Later Chemicals Ltd.: 45 (Later's Wasp Trap)
Longmans, Green & Co.: 1
McCain Canada: 136
Merck Frosst Canada & Co.: 117
Trevor Mills: 49 (top and bottom)
Ontario Hydro: 31
Orca Bay Hockey Limited Partnership: 7
Photo Technic: 1, 31, 52, 53, 54, 57, 85, 105, 140, 141
Selwyn Pullan: 140
Rothmans, Benson & Hedges Inc.: 16, 17 (Benson & Hedges, Craven A, Rothmans, Sportsman)
Royal Canadian Legion: 53
Sports Page: 34
Thamesville Metal Products Ltd.: 45 (Bulldog Steel Wool)
Lynne Vigue: 58
Western Living Magazine: 140
David Weir: 56

Pages 4/5: Roberta Bondar, *Tanquary Fiord looking toward the Grant Land Mountains, Quttinirpaaq National Park, Nunavut*

This book

contains eleven still life photographs I made for several reasons, the simplest one being that I wanted to create images understandable only to Canadians. Americans should look at these photos and think, "Huh? Everything looks familiar, and yet nothing is familiar." To accomplish this insider-only goal, I used the nearly extinct visual mode of the still life. I wanted the formal beauty of the still life to draw in the viewer, and then confront him or her with icons and forms which draw on our nation's shared memories, both humble and noble.

Segments of the book are ordered alphabetically—and loosely at that—a style of arrangement both poetic and random, yet effective in its own way.

This book is dedicated to my father—a more Canadian man is harder to imagine, and to follow in his footsteps is the deepest of honours.

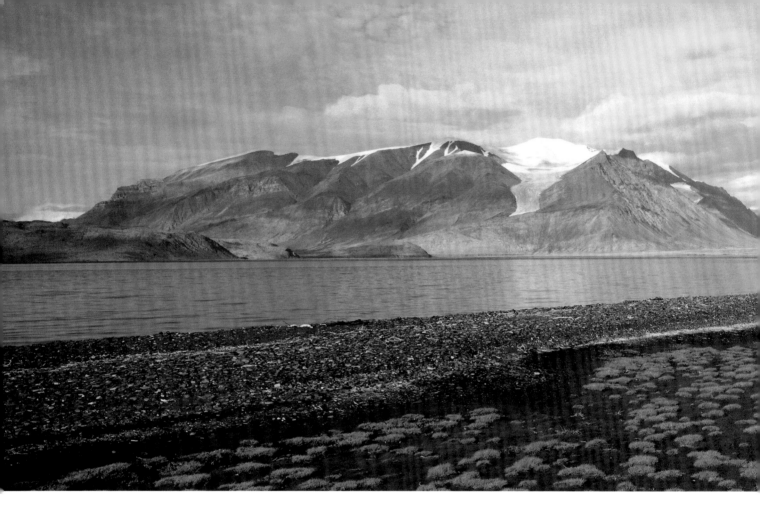

Start: # Baffin Island

I fly more than most people. On a recent flight to Frankfurt I sat and mapped out my past twenty years and made a count: I've flown across Canada a conservative total of fifty-five times, most likely more. And then there have been the times flying not strictly across Canada, but over it—to and from Europe—above Hudson Bay and the Ungava Peninsula, Ellesmere Island, Baffin Island and other of Canada's extreme northerly spots. There's just all of this *land* down there, blank and essentially uninhabited, no roads or power lines—just *land,* and maybe a spot of lichen. There are parts of it even the Inuit must look at, shake their heads and shrug in wonder. Down there is the land that time and space forgot. Down there are the First Nations inhabitants—roughly twenty-seven thousand—of Nunavut, a new territory created in 1999.

Also down there on the frigid rocks lie the remains of the Franklin Expedition, nineteenth-century sailors who tried to find the Northwest Passage to Asia and who went crazy from lead poisoning—their food was in tins soldered with lead.

And down there lie the petrified remains of a tropical rain forest, palms and cycads made of stone, rubbed by the arctic chill for a hundred million years.

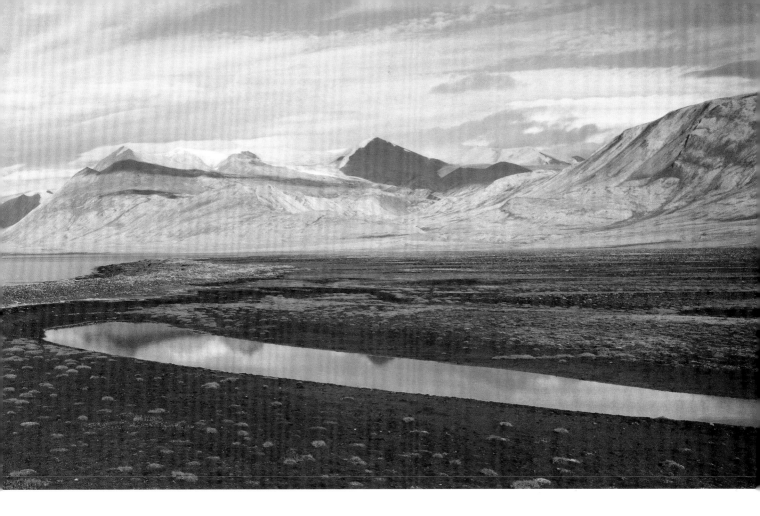

What is a Canadian in a 747 en route from Vancouver to Frankfurt supposed to make of all that seemingly dead or dormant land? I often wonder if I'll ever set foot on it, and pretty much doubt it. Will these vast refrigerated stones someday harbour modern cities and societies? Corner malls with a Lenscrafters and a Baskin-Robbins on Baffin Island? The Great Slave Lake Expressway? Do the Inuit visit Canada's south, see trees and wonder the same thing about us— how can these people live in such a freakish place? What does it *mean* for Canadians that we own these huge rocks if there's really not much we can do on them? Is it really ownership? If not, then what is it—babysitting?

Sometimes I imagine going to the airport and buying a ticket to Yellowknife, which is as far from the 49th parallel as Toronto is from Winnipeg. From Yellowknife, I'll hop a local flight and go up to Inuvik, possibly the world's most northerly community. The national news on TV always announces the temperatures in the big cities as well as the Inuvik temperature—a strange but genuine way to bond with this far-off piece of Canada.

Canada™

My high school had a work-experience program in twelfth grade, in which mumbling students were shunted off to spend a week at a job that seemed even fleetingly like something they might be good at. All I wanted was to get out of school, so the guidance counsellor plopped me into an advertising company's office. There, I did my best to not be in people's way and watched the clock for escape time.

The agency was in charge of inventing a new beer for a national brewery. This was mildly interesting because, with alcohol, the goal is to make people choose a very specific form of oblivion. This requires a mixture of art, alchemy and a dash of sleaze, and thus is not without entertainment value.

After much labour, the firm came up with a name for this new beer: Ryder. The logo was sort of a carefree handwritten script like those found mostly on women's hygiene product boxes. It was brown on a pale yellow background.

"What's with the logo and colour scheme?"

"It's manly. Outdoorsy. Rugged. It's supposed to look like a cattle brand."

Silence. Disbelief. "Why the name Ryder?"

"It's a name a cowboy would have."

"A cowboy would be named Ryder? It's like a porn star name. Or a male model. Rider *maybe*. But with a 'Y'? No way. What other names do you have?"

"We almost went with Tucker."

"Well, that's at least better than Ryder. Why didn't you use that?"

"Because people might take a felt pen and turn it into Fucker."

"Are you *crazy*? You should be so *lucky* to have that happen. It'd go to Number One overnight."

"Well" (you [underage] little twerp from the suburbs) "what do *you* know? If you were going to design a beer, what would *you* do?"

I jumped into action. "You have to make a label covered with ornate signatures and crowded typography to make it look like it's been around forever. Like this—" I sketched out something that looked like a cross between a ten-dollar bill and a menu from a railway hotel in the year 1910. It garnered sniggers.

Within a few years Ryder was dead, and an ancient brand called Extra Old Stock, ornately labeled and nicknamed High Test, had emerged from years of obscure sales to become the darling of beers.

Vindication.

The point to this whole story is that around 1980, Canadian history, or the idea of Canadian history, went from being something taught in schools to becoming something that was processed and sold back to us as a product. I suspect I was more sensitive to this transition than most because I went to an experimental school, where Canadian history was, in hindsight, pathetically taught, or not even taught at all. Twelve years of school and not once a mention of the Plains of Abraham—what were they thinking?

Anyway, for decades Canadians have been hamming it up with souvenirs for sale to tourists—teepees, Mounties, rugged mountainscapes—but it's only been since around 1980, just over a century into our nationhood, that we began selling ourselves to ourselves. Beer is still the most ruthless product category when it comes to manipulating Canadian imagery to further its own aims. And this isn't a put-down—good for them, I suppose. As well, in the 1990s, Disney, of all entities, was given the franchise to license all RCMP spinoff merchandise. But this is iffy territory. We have to watch out, because our reservoir of myths is far smaller and far more fragile than those of some other nations. Once the supplies dry up, they dry up. What happens then is that you start recycling myths, which turn into clichés; and before you know it, history has turned into nothing more than clip art.

Canuck?

Americans have pulled me aside on several occasions to ask, in the hushest of tones, "Is it, you know, *rude* to call Canadians Canucks?" When I say that it's perfectly fine, I get a disbelieving stare. So then I say, "There's even a hockey team called the Canucks," and only then do they relax. Yes, it's okay.

In a similar vein, on December 26 we have a holiday called Boxing Day. Whenever Americans ask what Boxing Day is—and I've been asked this maybe a dozen times—I tell them that it's the day after Christmas, and that there's no ritual or costumes or anything else attached to it—it's simply called Boxing Day. And the Americans always think that I made up the holiday on the spur of the moment.

Left: "Johnny Canuck," an early logo of the Vancouver Canucks hockey team
Right: The beloved "rink and stick" Canucks logo used from 1970 to the end of the 1977–78 season

TORONTO MAPLE LEAFS

Les Leafs de Toronto

Toronto Maple Leafs

21 BOB BAUN 70/71

8 JIM DOREY 70/71

19 PAUL HENDERSON 70/71

14 DAVE KEON 70/71

4 MIKE PELYK 70/71

1 JACQUES PLANTE

6 RON ELLIS 70/71

30 BRUCE GAMBLE 70/71

24 BRIAN GLENNIE

12 JIM HARRISON 70/71

2 RICK LEY

23 BILL MacMILLAN 70/71

18 JIM McKENNY

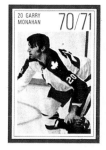

20 GARRY MONAHAN 70/71

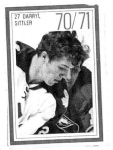

27 DARRYL SITTLER 70/71

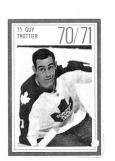

11 GUY TROTTIER 70/71

9 NORM ULLMAN

16 MIKE WALTON 70/71

Capitaine Crounche

Canadian companies frequently have names that function both as French and English names: ... Rapidair ... Canadair ... VIA ... Onex. When you're young, you don't know this, so more than a few times you wonder why Canadian names are so boring.

... Air Transat

... Alcan

... Inco

... Petro-Can

And then there are also products that not only have a different English and French name but also drastically different attitudes toward on-package hype. While the copy on each side of, say, a potato chip box, is given a mathematically equal amount of space, an English-language starburst will explain, "Chip-dilly-willy-icious!" while the French-language starburst will demurely state, "Bon Goût."

And then there are products whose name in French eclipses the product's English name. A salty snack food called Méli-Mélo comes to mind. In English, it's Bits & Bites ... not the same.

Sometimes the French name is so bizarre and cool looking—Capitaine Crounche or Mistigri—Alley Cat—that you just have to accept the fact that Canada is, in some obtusely Star Trek manner, a parallel-universe country, with two variations existing alongside each other; and through the miracle of nationhood, we bounce back and forth between the two universes.

Cheeseheads

While I was collecting food items for a series of photos, some of which appear in this book, I was struck by how odd it was that foods that felt intuitively "Canadian," when assembled together, looked more like camping trip provisions than actual groceries. The foods of France may be legendary, and American cuisine may be a joyous hash of Pop Art and military science, but Canadian food? A French newspaper once asked me to try to define Canadian food, and the best description I could come up with was, "It has to come from a box." I didn't mean this as a put-down or a put-up. It felt like the truth.

Canada is a cold and northern country. Aliens assessing the national diet would note that, from a biological standpoint, it is imperative that citizens live on concentrated forms of sugar,

carbohydrate, fat and salt. "Look, Zoltar! These Canadian beings prefer to stockpile their energy sources in cellulose units called 'boxes'—or if a box is unavailable, they use metal cylinders called 'cans.' "

Donuts …

Baloney …

Peanut butter …

Bacon …

Maple syrup …

Beer …

Potato chips …

Canned beans …

Processed cheese food products …

My father has a cache of tinned food he takes with him every time he goes hunting or fishing. Part of his cache is this one can of baked beans that quite honestly must predate the moonwalk. The thought of it sitting in his cupboard at this very moment is disturbing on a deep level. It's just sitting there, but what's going on inside it—is it in permanent stasis? Is it breeding? Is it petrifying? Would eating it kill him?

Last year in Milwaukee, Wisconsin, I was in a gift shop and saw big yellow foam cheese wedges for sale—they were hats worn by locals to football games. It reminded me of driving up Interstate-5 from Seattle into Canada and seeing CHEESEHEADS GO HOME spray-painted on the highway overpasses, cheeseheads meaning Canadians who buy American cheese to cash in on lower U.S. cheese prices. Talk about a slur.

Cheese, in fact, plays a weirdly large dietary role in the lives of Canadians, who have a more intimate and intense relationship with Kraft food products than the citizens of any other country. This is not a shameless product plug—for some reason, Canadians and Kraft products have bonded the way Australians have bonded with Marmite, or the English with Heinz tinned spaghetti. In particular, Kraft macaroni and cheese, known simply as Kraft Dinner, is the biggie, probably because it so precisely laser-targets the favoured Canadian food groups: fat, sugar, starch and salt. Most college students live on the stuff, and it's not the same as American Kraft Dinner—I've conducted a taste test and find there's something slightly chemical and off about the U.S. version. I invite you to take the taste test. I'd be happy to hear your conclusion.

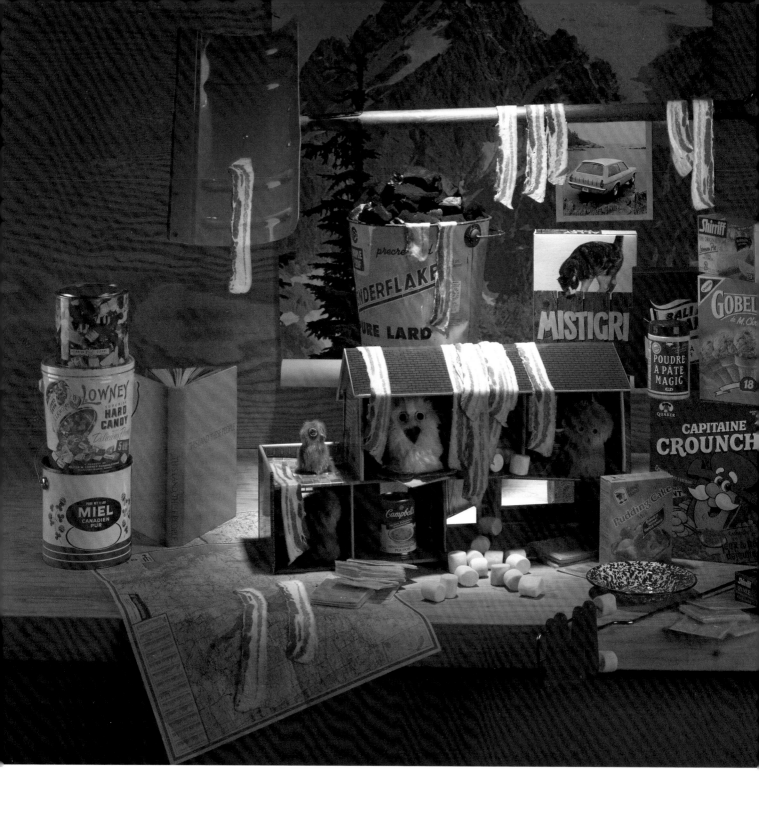

Chimo

In 1970 my brothers and I raised a pet Canada goose named Chimo. (I miss you, old buddy!) Chimo was the smartest and most loving bird of all time. And the name Chimo was just this superCanadian thing: for three short weeks around August 1970, it was hip to say "Chimo!" to someone on the street. Canada had gone Chimo-crazy.

Oh God (take deep breath here) … sometimes Canadian stuff is truly impossible to explain to outsiders. Chimo would fit that bill. It's this Canadian word, Inuktitut *possibly,* but nobody's too sure what it means—it's kind of like aloha/hello/good-bye/ciao/à bientôt. Common suspicion is that the word was dreamed up in a government office during the late 1960s big-money days of Canadian nationalism: "Canada needs its own national greeting—quick—take several million dollars and cook one up. And don't bother about keeping receipts."

Chocolate

If there is one subject on which Canadians and Americans are bitterly—and possibly irreconcilably—divided, it is candy bars. In 1993 a trio of young journalists from a U.S. magazine called *Dirt* (long defunct) visited me in Vancouver. *Dirt* was a funny and smart magazine for young people, which at that time still just barely included me. They were in town for a few days, and we hit it off. A few weeks later I was in Iowa City, Iowa, and the same trio was passing through town, so we hooked up. Before leaving Canada they'd bought one of every Canadian chocolate bar, and then, while driving through Devils Tower National Monument, they decided to rate the quality of Canadian chocolate bars for a magazine sidebar. I couldn't believe the low ratings that Canadian chocolate garnered. Americans find Canadian chocolate too sweet, while Canadians consider U.S. chocolate bars too waxy, unrefined and peanutty. To add insult, the *Dirt* crew invented the Prairie Dog Test. They threw half-eaten chocolate bars to the prairie dogs, and if the prairie dogs grabbed one and took it down their holes, the bar got an extra point. Ignored bars lost a point. *Scandal.*

So we went to the local convenience mart and bought one of every American chocolate bar, and then up in the hotel room we had a taste-off. This was just like a wine tasting, but instead of a mouthful of wine, it was a bite of chocolate bar, which I rated and then spat into a wastebasket. It was utterly silly but utterly serious at the same time, because when you slag a nation's chocolate bars, you're slagging the childhood memory banks of that nation's citizens.

As it turned out, American candy bars scored as badly as Canadian ones. Again, this wasn't an ICBM treaty or something, but it was definitely real.

One of the rating categories was appearance. I described one bar in particular as having a toilet-bowl aspect to it. Unfortunately, its makers were one of the fledgling magazine's few advertisers. They pulled their ad and the magazine failed. Score one for Canada.

Cigs

One sunny afternoon in the 1990s, Canada's prime minister was wearing Ray-Ban sunglasses. This was in Ottawa, on Parliament Hill, and he was walking from wherever to wherever, accompanied by a scrum of a crowd. During this walk, he was pestered one too many times by a persistent heckler who'd been on his case for a long time. The prime minister snapped, and a photo of him strangling the heckler went out on the wire services. The day it appeared in newspapers, I got three e-mails from Americans saying, "Wow! It's so great that you have a prime minister who wears Ray-Bans and strangles people. I wish we had a president like that." I mention this story to introduce the fact that strange causes can have even stranger effects on people. For example: *cigarette packaging.*

If you smoke in Canada, every time you reach for your pack you encounter a huge, screaming black-and-white statement that reads: CIGARETTES CAUSE CANCER. That simple. Or something equally frightening. As an added bonus, there are countless grotesque photos of diseased you-name-its appended to the words. These warnings have been growing in size for years, and they now remind me of avant-garde art from New York in the 1980s. They're backwards hip. I quit smoking in 1988, but these new packages are so cool looking that, human nature being as perverse as it is, they almost make me want to start up again. And as of recently, cigarette manufacturers are no longer going to be able to use the words "mild" or "light" on their boxes—Emphysema Lite, Cancer Mild.

Visit the U.S. where they pussyfoot like mad about tobacco (THE SURGEON GENERAL THINKS SMOKING MIGHT NOT BE THE BEST IDEA, BUT THAT'S ONLY ONE PERSON'S OPINION), or Europe, where they don't bother with anything at all, and it makes me kind of proud that Canada's telling the truth. It'll be a decade before we know if the new tactic works. I suppose these Canadian cigarette packs will only become more and more collectible as the years pass, joining Victorian dental tools and 1960s gerbil toys as a beloved collecting category.

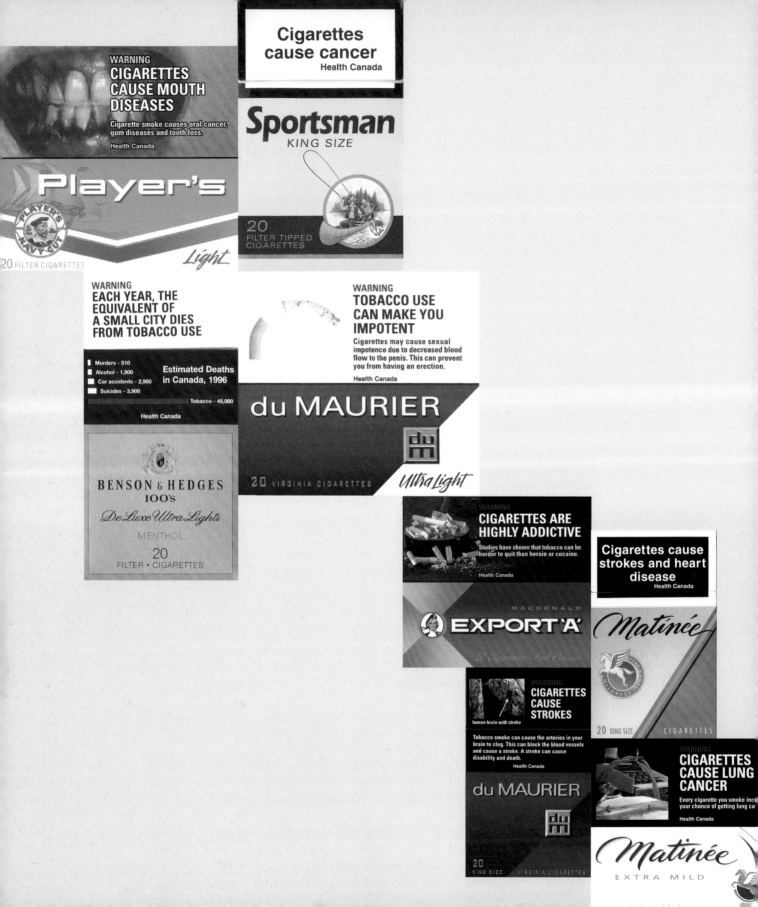

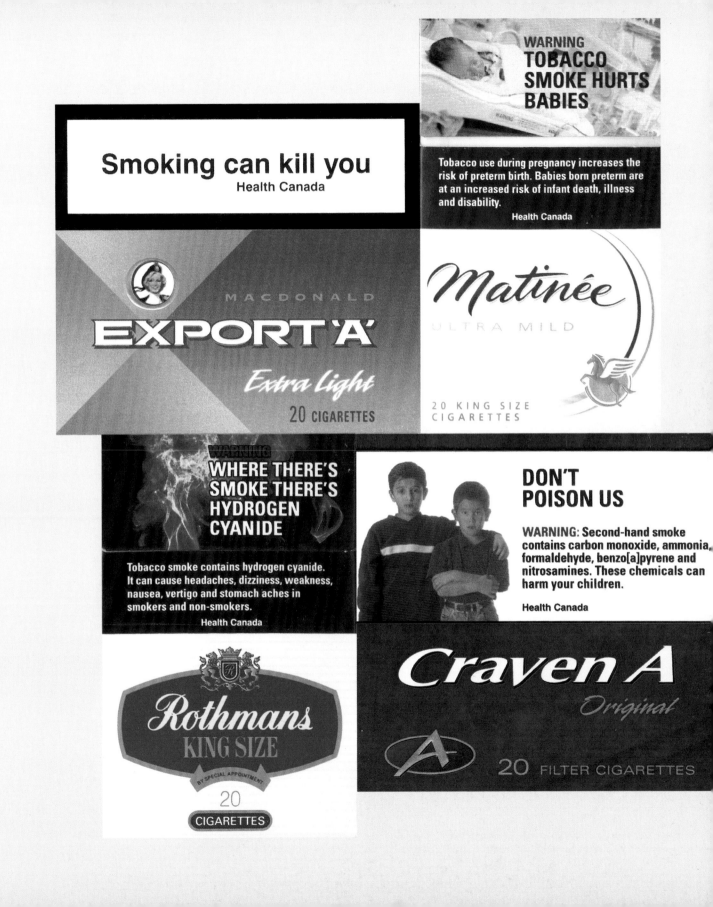

Clans

Every few years I have to go through Newcastle, England, on business, and I quite look forward to it. In a genetic sense, about seventy per cent of my DNA comes from the region just north of the city, up near the Scottish border. There's even a little (and this is the first time I've ever been able to use this word in a sentence) *hamlet* there named Coupland.

The citizens of Newcastle and environs, for obvious reasons, look like most of the people in my family, and to walk through the streets there is to walk through a parallel universe of people who could just as well be relatives. Some of them likely are. But the sensation of being among your own, and *only* your own, while fun for the first while, rapidly takes on the texture of a science-fiction movie where pod people have supplanted a region's citizens. It is eerie. There is no other word for it. And this is the point where being Canadian really hits home, because what you want, and what you're missing, is the variety of people you see in Canada—certainly in Vancouver. I know we're all supposed to love being multicultural and all of that, and we all know how that works and how to play the game and talk the talk—but to *crave* it and feel deprived without it is another sensation altogether. It's one of those things that lumps your throat and makes you realize that things will probably work out in the end.

CN Tower

When you go to Germany and visit any city with a population over a million, that city will have a TV tower. These were mostly built in the 1970s, back before satellites, optical fibre and mobile phones rendered TV towers semi-pointless high-tech totems. Their vainly futuristic styling evokes a now-dead period in human technological history—the broadcast era. TV towers also tend to have revolving restaurants.

In 1974 and 1975 Canadian papers and TV were full of news about an elegant tower—the world's tallest—being built in Toronto. To North Americans, this construction was more exotic than it might have been to Europeans; Canada and the U.S. have no real tradition of the TV tower. San Francisco's Sutro Tower springs to mind, but it's just steel girders and has no civilian access, let alone a revolving restaurant. But the CN Tower—*yow!*—it was so totally mega-mega, and its height made you feel proud because it reminded you of how vast Canada is. I suppose it's just one more manifestation of the national necessity for communicating across wide distances. Alexander Graham Bell would have approved.

But the CN Tower also speaks of the rah-rah nationalism that saturated Canada's air from Expo '67 to the 1976 Montreal Olympics. In the end, you also really can't deny the fact that the tower is just a plain, old-fashioned phallic symbol—just as much as some of the stone *inuksuit* of the Arctic. And like the inuksuit, the CN Tower also serves as a guidepost; for those who live in Toronto, it's an instant, omnipresent marker that says, "Lake Ontario? Right here, thank you."

I really like the damn thing—and there must be *something* more we can do with it now that broadcasting isn't an imperative. The twentieth century feels like a million years ago, yet its passive consumer CN Tower dream remains seductive: Singapore Slings, roast beef and mashed potatoes while revolving at 350 metres (1,150 feet)*; on a clear night you can see Rochester, New York, across the lake. It was a simple but real dream.

I hear that science is now ready to use frozen DNA to bring woolly mammoths back from extinction. So maybe the next version of the dream will be food-based: instead of roast beef, we'll eat woolly mammoth on top of the CN Tower, and some vast cosmic circle of progress will have been completed. I want to book my table *now*.

* For the record, efficient and decimal as it may be, I hate metric.

Canada Picture No. 02, 2001

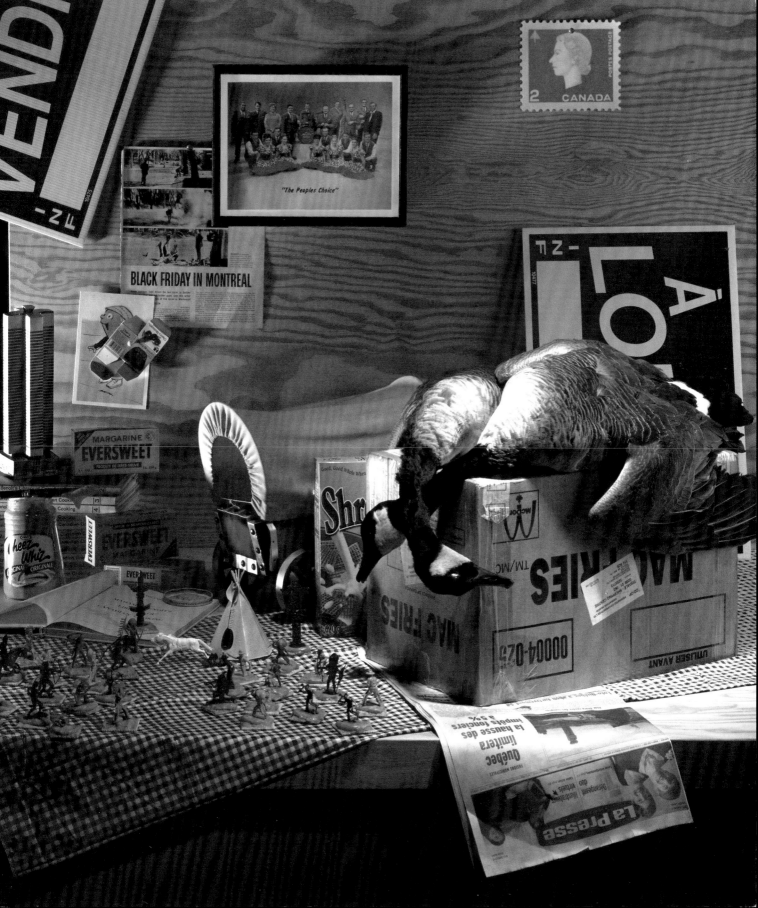

DEW Line

Everybody remembers one or two movies which, when you watched them at the age of nine, frightened you sick and made getting to sleep difficult for the following few years. Mine was *Lord of the Flies,* the old black-and-white version. After seeing it, I didn't sleep for a month, and even thinking of it makes me feel almost seasick. So imagine what it was like to see the same scary movie, whatever it was for you, over and over again, every day for your entire upbringing. This is, in essence, what it was like to grow up during the Cold War.

In the 1970s, one of the first things we learned when studying geography is that Canada lies between the U.S.S.R. and the United States. World War III was slated to begin above the Canadian north—that never seemed to be negotiable when decoding the strategies of both superpowers—and thus Canadians were stuck with this grim geographical situation. Because back then there was no Star Wars or any other pre-emptive missile deterrent (if such a thing is even possible, I mean, these suckers are *fast*), the best Canada and the U.S. could do was to construct distant early warning (DEW) systems, which could at least offer a fifteen-minute warning so that we could counterattack and ensure the end of civilization as we headed for bunkers. Clever! And now that the Cold War is over and a new one has begun, it turns out the Soviets' defence line was essentially made of papier mâché and their missiles were directed by McDonald's french-fry cooker computers.

Three lines of detection were built and operated by NORAD, the North American Air Defense. First was the Pinetree Line, begun in the 1950s, which lay a few hundred kilometres north of the U.S. border. Second was the DEW Line, completed in 1957, much further north into the Arctic. Last was the short-lived Mid-Canada, which was set up in 1958, and roughly followed the 55th parallel. It was disbanded in 1965.

These sites, many of which operated for more than forty years—a few are still going— were extraordinarily expensive to build and maintain: cities created overnight in the harshest land God ever laid eyes on. They had a profound and subtle impact on the Canadian psyche. One simple and practical example is that more than forty thousand Newfoundland women ended up marrying American servicemen. Another is that in the 1950s, Goose Bay, in the frosty unloving heart of Labrador, was the world's second-largest airport—*second-largest*—servicing the vast fleets of bombers and cargo planes necessary to keep anti-Soviet vigilance in action.

On an insidious and more potent level, the existence of the DEW Line made the sky something to fear. Nowadays nobody trusts either the sky or the weather, but in a perverse example of one-downmanship, it was we Canadians who first looked up at the blue and said to ourselves, "Oh God—when does *it* happen—now?" It was the unimaginable horror that could zip out of the northern lights or the Milky Way in a moment.

My father flew fighter jets in the Canadian Armed Forces in Germany, where I was born. When I went back to the base for a visit in 1980, jets of staggering loudness screamed over the place every seventeen minutes—noise so loud it shortened your life. When I asked my mom how she had put up with it, she said, "Oh … ha ha ha—you get used to it. You don't even notice it after a while." Now, decades later, when the topic of the Cold War comes up and we mention how it scarred our psyches most likely forever, my parents say, "You should have mentioned it—we never thought it might have bothered you." As Charlie Brown said, *Aughhhh!*

Doug

An Austrian TV journalist was in Vancouver doing a piece last year, and I was there to help out. He said to me, "I hear that everybody in Canada is named Doug." I said, "Ha ha ha, that's just a media myth." And then the hired three-man crew arrived, and they were all named Doug, and suddenly there were four Dougs there, and I had to drink a glass of cold water to make sure that I wasn't dreaming, and in some intangible way it felt as if I were doing my national duty. I was then asked if Canada had a stereotypical girl's name. I had to think about it, but if we do, here it is: Kathy.

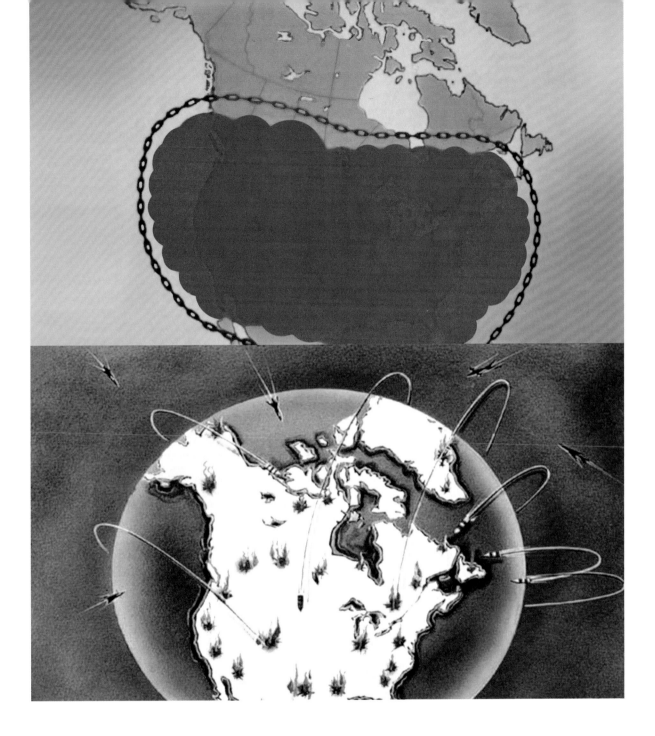

Distance

You can never overstate how large a country Canada is. Everything is far away from everything else; nothing is close to anything. And a sizable chunk of the Canadian identity is defined both by how we pretend this isn't the case, and how we can be so shockingly cavalier about plane hops like Vancouver to Winnipeg or Montreal to Halifax. In Europe or Asia, such distances would cover a half dozen countries and societies. In Canada, all it means is that the baseball cap at the other end has a different team's name stitched onto it. Canadians are the same as Americans about this—Texans will drive two hours to go out for dinner. But whereas the continental U.S. has cities plunked about its forty-eight states with quite equal spacing, Canada (at least the inhabited part) is a skinny Chile-like entity that stretches across the continent. To the north, for millions of square kilometres, lies nothingness, and this vast space looms large in the Canadian mind. In our national anthem, it's called the True North strong and free.

I often think of the country's pioneers—my ancestors, the homeless people of Scotland and Ireland—plopped into some hellish blackfly-infested patch of roots and snow and rocks and killer mammals, the nearest other settlers an arduous half-day's travel away. They must have gone insane with the desire to communicate with someone—anyone—outside of their drab, hostile little realm. It comes as no surprise to me that a displaced Scot invented the telephone in semi-rural Ontario, Brantford. Finally, a way to span all of that pesky and saddening distance.

Pages 24/25: Sweet dreams! These NORAD images used in elementary and high school education illustrate the sort of geopolitical images absorbed by Canadians from the late 1950s up until the late 1970s.

Page 28/29: Canada Picture No. 03, 2001

England

For centuries Canada has been an escape route for Brits who want to ditch the idiocy of the class system. Of course, once they're here, they pygmalionize into SuperBrits: accents move up a few notches and gin is displayed prominently in liquor cabinets. I once assumed that English-Canadians would be thrilled to meet a fellow expat, but after a few disasters, I've realized this is the last thing they want. ("Did you see the way so-and-so was poshing it up in there? 'Oh look at me, look at me—I'm so BBC2!' ")

In 1980 I had a brief summer job in the tourist trap section of Vancouver—it was a place where we would look up your family's coat of arms in a huge catalogue, and then, for a fee, you could order a wide range of (just say it, Doug) crap emblazoned with your personal heraldry. I asked the owner why he'd chosen to locate the store in the tourist trap instead of, say, a mall, and his answer was insightful: "When people leave home and come to a new place, their identity dissolves; they try to shore it up by buying coats of arms merchandise—or KISS ME I'M VENEZUELAN T–shirts—it reminds them of who they are." Likewise, this is why religions target airports to find new recruits—the psychic vulnerability caused by travel. Or, for that matter—and it's just this weird thing I've noticed over the years—people who read diet books or self-help manuals during long air flights tend to absorb and believe these books with a ferocity that can be stunning. One woman I know nearly died after reading a crackpot diet book while flying home from Ottawa; she refused to believe it was anything but gospel. Maybe it has something to do with being in a plane, or perhaps, more precisely, being untethered from earth, which makes us so porous and susceptible.

I've gone through all of this to point out that much of Canada's Anglophilia came about because one of the first and largest waves of immigration to the country were deliriously homesick Brits stuck in what was then, culturally and cartographically, the Middle of Nowhere. They had to amplify their Britishness in order to maintain a grasp on their self-identities. But I think that Anglophilia is waning because Canada stopped being Nowhere some years ago, and the effort to shore up their sense of self in the tea-and-crumpets mode is no longer necessary. In a similar manner, most immigrant waves who come to Canada ham up the clichés for a while until they get their new identities in order. And then they assimilate and become, for whatever it means, Canadians.

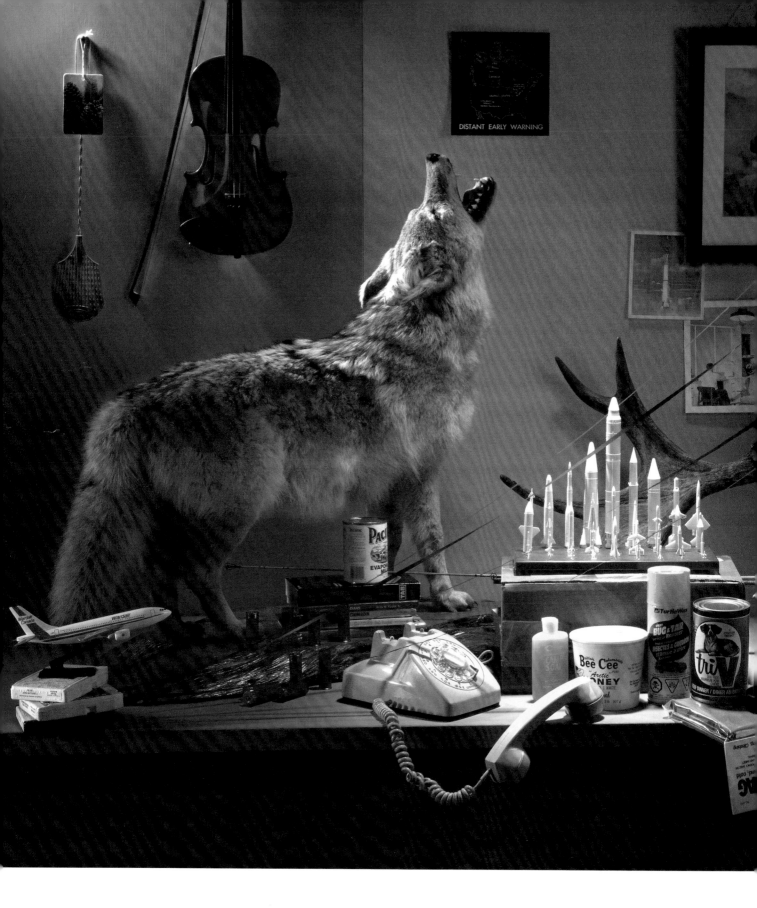

Flies

In July of 2000 I was filming a clip for CNN atop Vancouver's Grouse Mountain when I ate a fly. Or rather, it flew into my mouth, I freaked out, and down it went. The camera people couldn't have been more amused had I tried, and I'll never again sleep properly knowing that there's this footage out there of me and *the fly*.

In the summer of 1977 I was up at the family cabin in Quebec's Gatineau region. My cousin James and I were both fifteen, both given to acne and both walking salad bars for the local blackflies. Our *skin*—God, it was such a disaster—I mean, your teenage years are already hard enough, but…. To top it off, we were sunburnt. Then a well-meaning but cretinous family friend said that the best way to get rid of zits was to thoroughly wash our hair with Tide detergent twice a day—so we did. Needless to say, Tide did nothing for zits, but it *was* ambrosia for the blackflies. Our hair was soon converted into mouse-brown candyfloss. No photos of this summer have been allowed to survive.

In 1979 when I drove across Canada, I remember being in eastern Manitoba and the western part of Ontario, watching the windscreen build up a thick yellow ectoplasm of exploded bugs—a turnip mash of blackflies—and turning on the windshield wipers and being unable to see through the window.

I could go on. The larger point is that while everyone has their blackfly stories, Canadians have *more* of them. At their most benign, flies are an annoyance. (To be fair, we can throw in mosquitoes and chiggers here, too.) They're a buzzing chorus that blankets the nation. Collectively, it feels as if Nature is gossiping about us and not saying very nice things. At their worst, and in the most clinical sense, black-flies are the blood-sucking spawn of hell, intent on eating your flesh and laying their eggs inside of you so that the maggots can finish the job. They can wreck a trip to the outdoors far faster than a forgotten can opener or wet matches. They want you. They are lying in wait for you. You can't run.

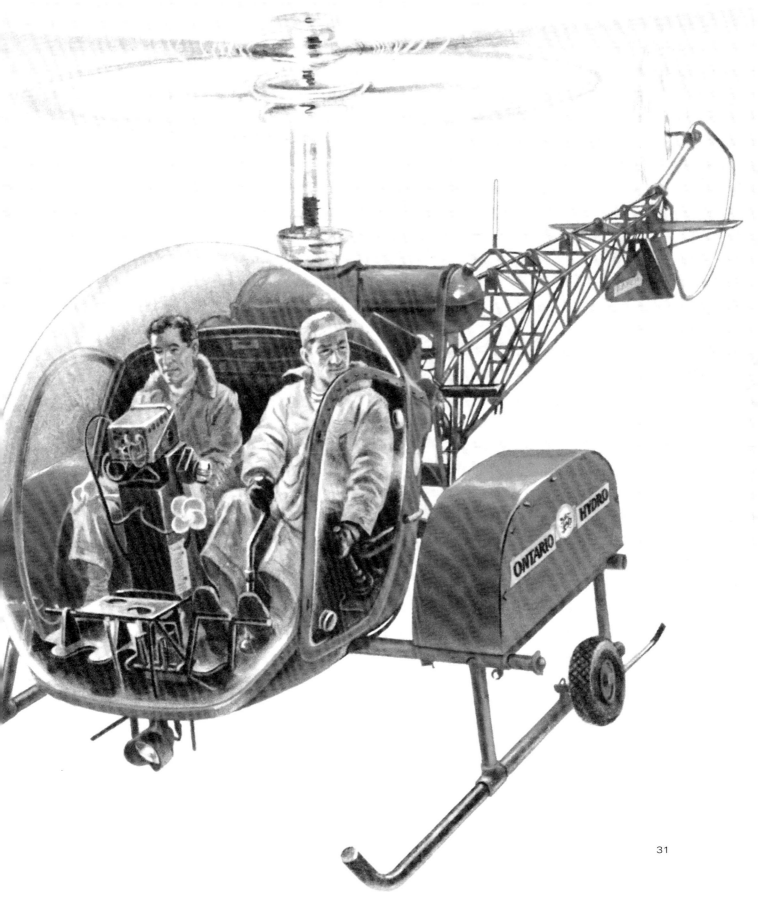

31

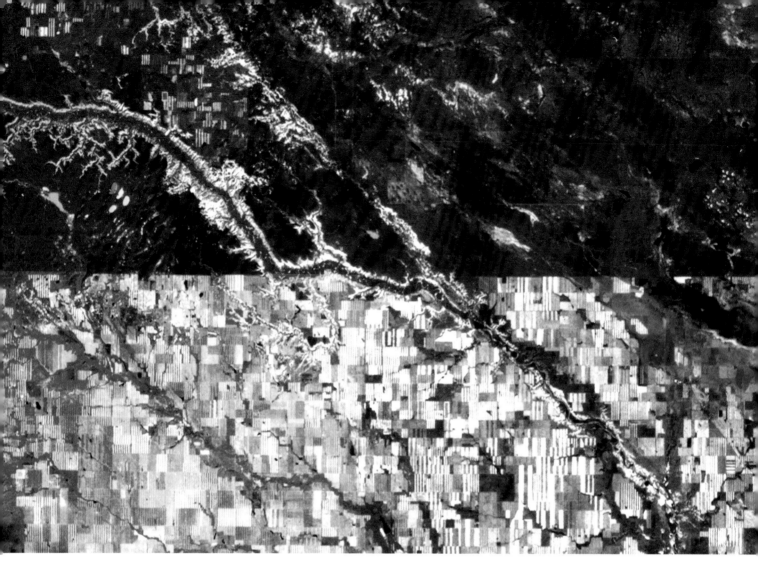

Canadian/U.S. border (Alberta/Montana)

Like all lines of latitude and longitude, the 49th parallel was just an arbitrary, imaginary line when it was chosen as the Canadian/U.S. border from Ontario to Alberta in 1818. Today, however, it is every bit as real and tangible as the differences between the two countries on either side of the line; it is almost as though the symbols of political economy have been carved into the land. The upper half of the image shows southern Alberta rangeland; below, the dense agglomeration of Montana wheat fields. The dramatic change in land use is not a function of soils or climate but of American agricultural policies that encourage and subsidize grain production and of Canadian policies that do not. The area shown centres on the Milk River, flowing southeast out of Canada and into the United States. Healthy vegetation is depicted in bright red. Recently harvested fields are white, while land left to fallow is a pale green.

As with most of the Great Plains, the rolling land on both sides of the border consists of poorly cemented silt, sand and gravel laid down in successive layers by parallel rivers and streams flowing east from the Rocky Mountains. Just out of sight to the northeast of this older Landsat image are the Cypress Hills, remnants of a 35-million-year-old plateau that has the rare distinction of being one of the few places in Canada bypassed by the last ice age.

49th Parallel

For Europeans, a map of North America has an exotic allure difficult for Canadians to fathom. Why? Because many of our borders are drawn with straight lines—like those of Saskatchewan, Manitoba and the Yukon—and the longest straight line of all, the U.S.-Canada border, which mostly follows the 49th parallel, is 8890 kilometres (5,524 miles) in length. To us it's everyday life, but if you come from a place where all borders are delineated by rivers, watersheds and battlefields, it takes a cultural leap of faith to cross an arbitrary straight line and suddenly be in Alberta, North Dakota or British Columbia.

Much of Canada and the U.S. was laid out using a grid, a craze of the nineteenth century. Not only states and provinces but cities, counties, townships and parishes, too. In Quebec a few centuries earlier, straight lines were used to delineate "seigneurial strips," long thin rectangles that touched on the colony's rivers. The mania for straight lines reached its ridiculous apex in downtown San Francisco, where a grid was slapped onto a near-cliff—*We will dominate nature! Give us cable cars!*

Europeans feel a bit cynical when they look at our ruler-straight borders. They simply don't believe that such capricious demarcations can weather the test of history. And in this they are correct. In fifty thousand years Canada won't have the same borders it has now. Obviously. In ten thousand years? No. A thousand years? Highly unlikely. Five hundred years? Maybe. A hundred? Who knows? Fifty years ago, the notion of Nunavut would have been inconceivable. So at some point the map of Canada will change, and it's torture not to know how and when this is going to happen. Will Quebec secede? Will Alberta? Will the Russians invade and conquer B.C.? Will we win Maine in a poker game? There are also entirely new means of creating borders. If a nuclear facility in Washington State melts down, the gargantuan isotopic egg-shaped dead zone that will be created downwind certainly won't give a hoot about the southern Saskatchewan border.

Let's look at the 49th parallel another way: if you were from outer space and were shown a topographic map of North America and then told to come up with the stupidest way possible to slice it up, you'd probably say, "Let's put a straight line right across the middle which totally ignores all ecosystems, biospheres and geological formations—that way we can permanently warp and cripple the citizens on both sides of the border." And yet this is exactly what happened, but not in such a conscious and deliberately playful manner. That would be un-Canadian, although as a vague rule, rivers above the 49th parallel flow to the north, and those below the 49th flow to the south. Even so, why use a straight line?

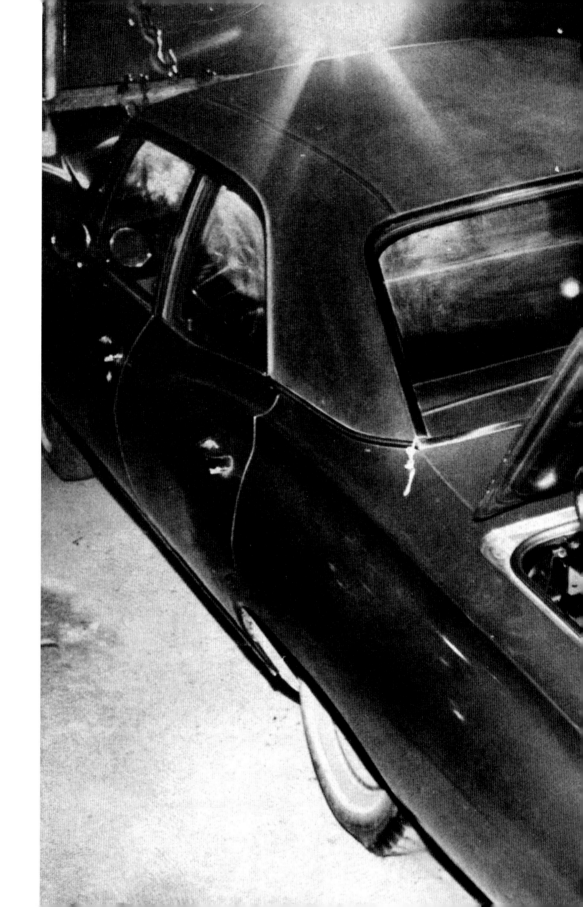

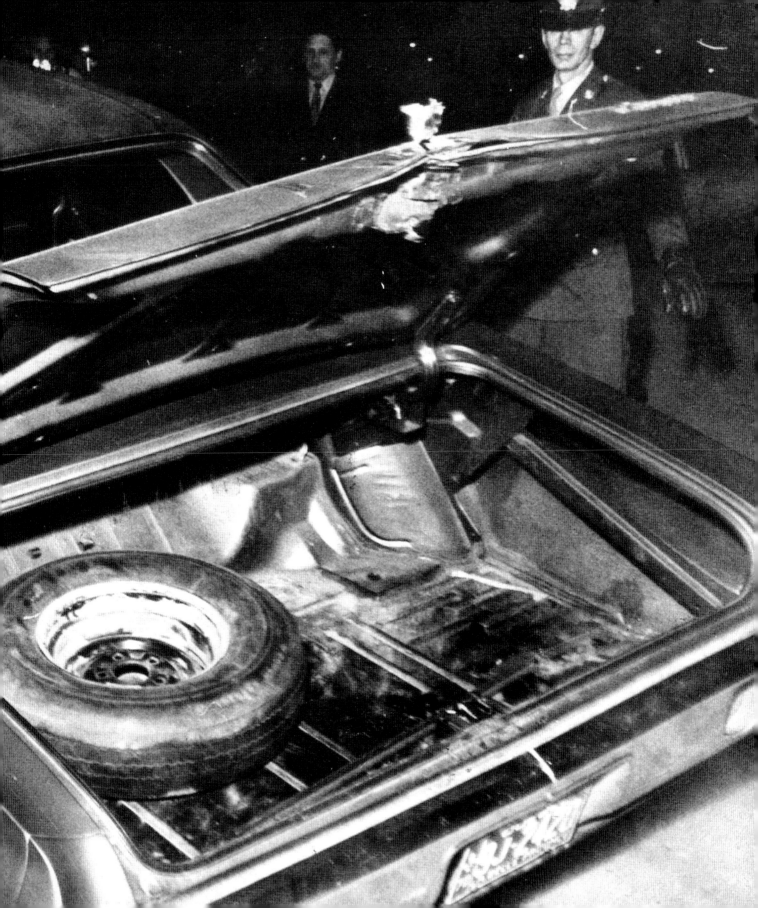

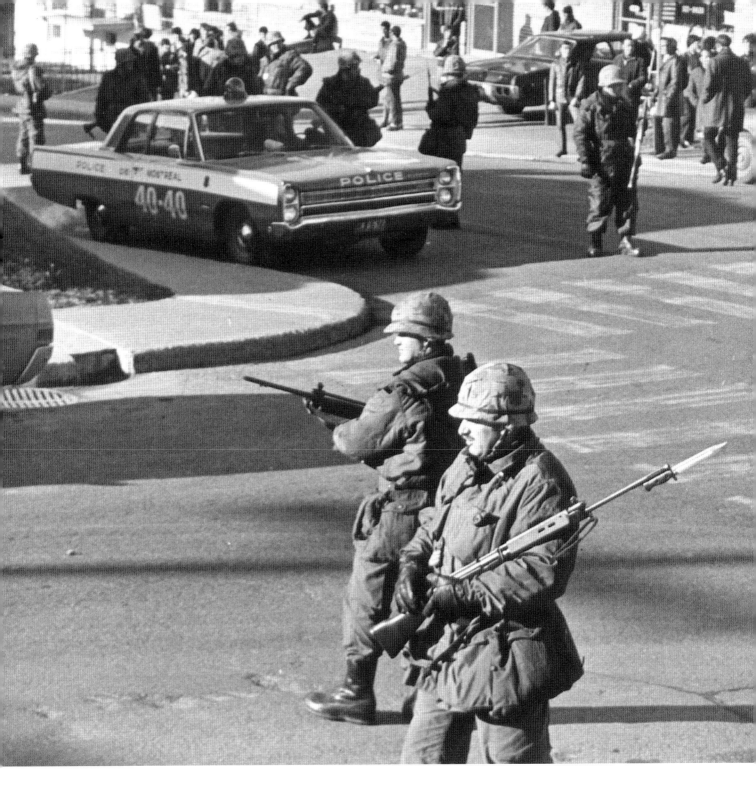

FLQG8FTAA911

In October of 1970, at the age of eight, myself and six hundred other students of Glenmore Elementary, School District 45, in West Vancouver, B.C., were brought into the school gym and told to sit on its freshly varnished floor and to be quiet. We were instructed to watch a small 12-inch (30-centimetre) black-and-white TV up on the stage. The TV had dismal reception and almost no sound. What we saw was the funeral of Pierre Laporte, Quebec's minister of labour. Laporte had been kidnapped from his Montreal home and executed by members of the FLQ, the Front de libération du Québec, who had left his corpse in the trunk of a car.

Decades later, two things strike me. One is that Laporte's body was found in the trunk of a 1968 Chevy Biscayne made in a General Motors branch plant in Ontario. The other is how emotionally wrenched the teachers were—they were palpably sickened and worried by the events being broadcast on TV. In 1969 Canada's social fabric was both unravelling and being reknit, and the events of 1970 were an extension of that turmoil. Canada as it had been up until then was vanishing and being replaced, it seemed to some, by anarchists, stoners and children.

The FLQ was very much of its era, the heyday of other terrorist groups within the industrialized nations of the west: Germany's Baader-Meinhof, Italy's Brigada Rosa, America's Weather Underground, and the high profile and dangerously loopy Symbionese Liberation Army.

The FLQ was concerned about who was actually running Canada and Quebec, and whoever they were, it obviously didn't like them. Its thinking singled out the "relay class" as the one group most in need of a forceful awakening. "Relay class" is a term used to describe the social elites who maintain a puppet government's power, either through direct involvement or tacit silence. While Canada's government is by no means a puppet one, our social elites have undeniably been relaying for the English, French and Americans for more than five hundred years. We trap furs for them, mine ore for them, build cars for them—and, in exchange, we get royal wedding tea towels and a pat on the back. The FLQ wanted both to expose this stranglehold on the economy and to free themselves from it. Whether you agreed with them or not, the FLQ did bring the matter to everyone's attention, albeit in a bloody and insane way.

It took more than thirty years, until April 2001, for dissent to again hit Quebec's streets. But instead of small secret terrorist cells, it was a large mob expressing anger, and it wasn't Quebec they were angry about. The mob had used Hotmail accounts to assemble in Quebec City to confront globalism in the form of a Summit of the Americas, whose goal was to further free trade between North and South America in "the Free Trade Area of the Americas" (FTAA). The new target was not so much a specific class tyrannizing a specific region, but rather, the target was a grey, soulless mist falling over the world, turning everything into either a sweatshop

or a generic cultureless discount highway mall. Conferences like the Summit of the Americas and G-8 seemed to be the only available points on which to focus collective disapproval of this fate. But four months later, after the events of September 11, such rallies had almost entered the realm of nostalgia.

The Québécois generation that grew up after the separatist era now inhabits a monolingual society that comfortably navigates between the rest of Canada and the rest of the world. Yet Quebec's dissent is by no means over. Four separatist governments as well as two do-we-or-don't-we? referendums are too powerful a legacy to abandon. The desire to split from the rest of Canada will resurface again. That's the way history works.

Pages 34/35: October 18, 1970: The body of Pierre Laporte, Quebec labour minister, was found in the trunk of this 1968 Biscayne at St. Hubert Airport south of Montreal.

Page 36: Halloween night, 1969: Demonstrators spray-painted an FLQ symbol on the window of the Banque Canadienne Nationale in Quebec City. The action followed demonstrations against the Quebec government's Bill 63, designed to guarantee the language rights of the English minority in Quebec.

Page 37: December 3, 1970: Two armed soldiers, one with fixed bayonet, patrol a street in north-end Montreal, where British Trade Commissioner James Cross was reportedly being held. FLQ terrorists had kidnapped Mr. Cross on October 5.

Page 40: October 16, 1970: A soldier stands guard by a Canadian Forces helicopter at the Quebec Provincial Police headquarters during the October Crisis in Montreal. Such a scene was unprecedented in Canadian history.

Pages 41/42/43: A group of silent protesters at Quebec City's Summit of the Americas in April 2001. In one sense, the conference was a disaster—political riots to rival anything from 1968 and a show of police force like something from a North Korean propaganda movie. On the other hand, most folks there deemed the event a success. Political activists (who would be the shaven-headed body-pierced anarchist anti-capitalists) made their points clear, while politicos (who would be like the plutocrat from the Monopoly board game) had lots of meetings and did summit-y things. Win/win!

Meanwhile, the general public tried to make sense of closed freeways, razor-wired barricades, water cannons, tear gas canisters and protesters who hurled teddy bears, boulders, burning Christmas trees, bottled gasoline and golf balls over those barricades. The general public also had to deal with mixed messages from and suspicions of the agenda of just about every party involved. One TV image that I remember is of protesters sticking their faces into snowbanks to stop the burning of tear gas. Another is of some guy in a Cisco Systems golf shirt, talking about Canada's overly restrictive gun laws. And to top it all off, after September 11, all of this seems somehow … sentimental and naïve.

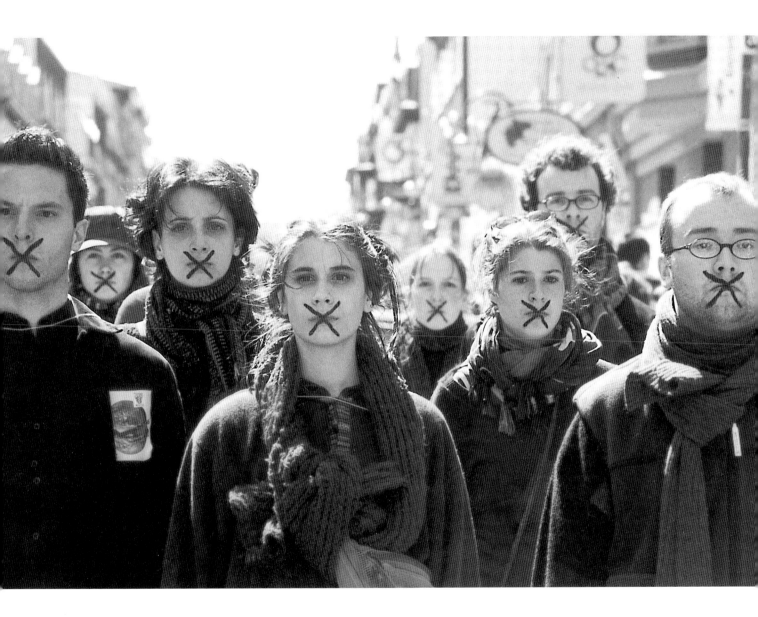

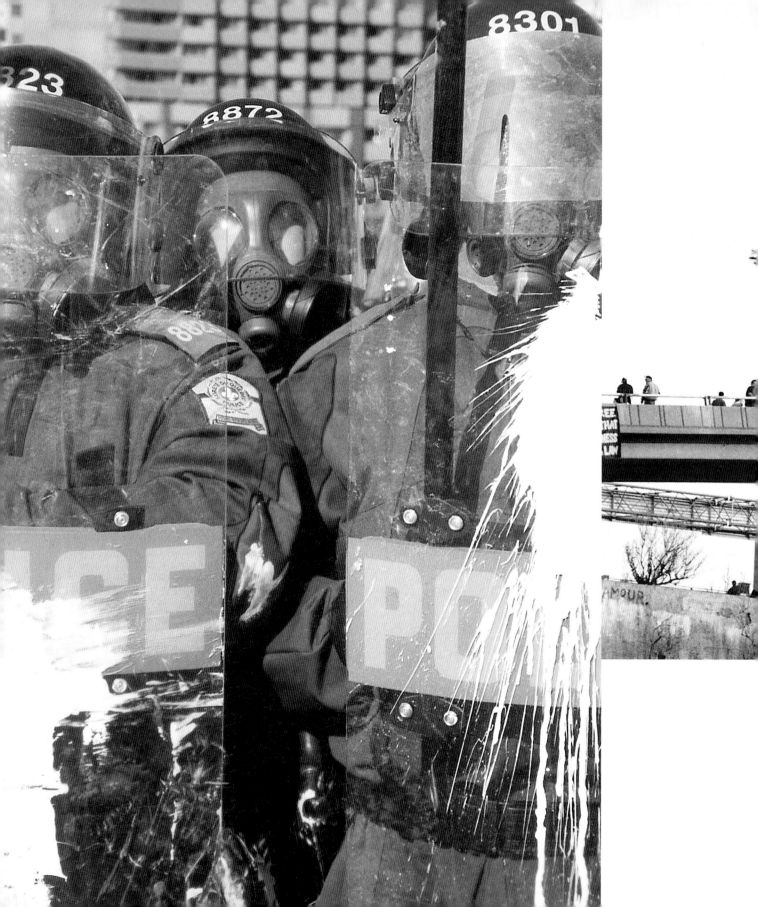

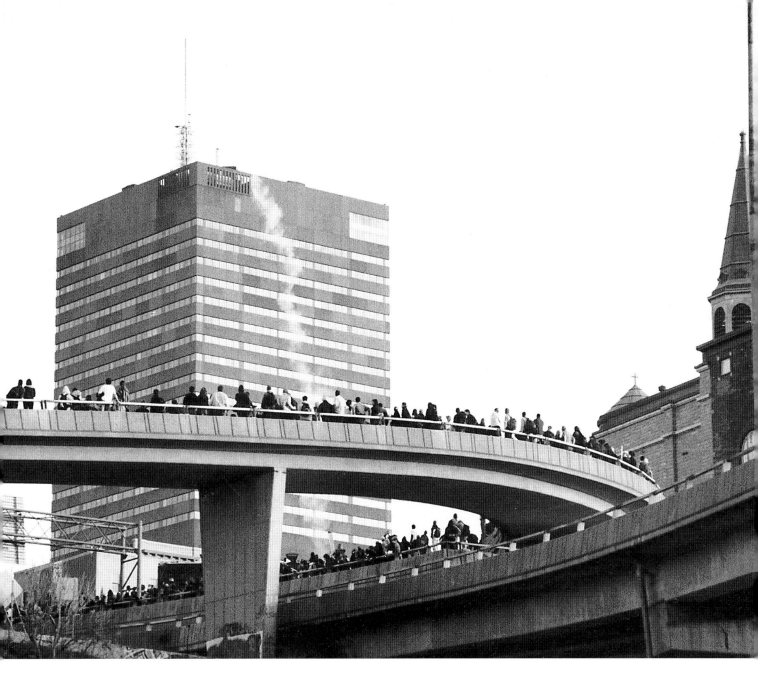

French

In 1969 Canada became officially bilingual. Since then, countless young people have dreaded the grade when French becomes mandatory. For me in B.C. it was grade eight, though that's changed since, and years vary from province to province. Regardless, the dread of French is not so much of learning a new language—most kids are totally up for that—it's that they can't believe many educators wait until our pubescent brains have lost their "eidetic memory processing" capacity. This is another way of saying that the same hormones that make the hair grow in your armpits are the ones that obliterate your brain's inborn ability to learn languages easily. Way to go, government Einsteins.

I'm fairly okay with languages. I remember that in October of 1974 when our French teacher asked if anybody in class knew the word for spinach, I actually did—*épinard*—only because it appears on cans, and I notice these things. The shock on her face! It was as if I'd pulled the sword from the stone. Meanwhile, everyone in the class seethed with resentment.

From there, it was a matter of destiny that I join the French Club, a profoundly not-cool entity, and surely as equally uncool as the English Club must be in any Trois Rivières high school. The French Club got me through five years of French in under three, and we went to Paris on a low-budget field trip; the touring coach van had only one tape, the disco classic "Fly Robin, Fly," which to this day reminds me of jet lag and room-temperature coffee with milk. After thirty-six hours without sleep we went directly from Orly airport to see the Bayeux Tapestry. At the *son et lumière* at the Chateau de Chenonceau, I met a British girl whose father had just purchased the Batmobile. Europe is wasted on young people. However, *do* note that the French Club's organizers sent us to Paris—*not* Montreal or Quebec City. Montreal is the world's second-largest French-speaking city, but because it's in our own country, it's not *French* enough, which must surely drive the Québécois nuts. A manifestation of this might well be their Bills 101 and 178, which harshly limit the use of English on signage and other locations. For a decade, I thought it was evil and fascist and all of that, and now I'm thinking, *Good for them for not allowing themselves to be turned into Louisiana.* Similarly, I have to admit that for years I always kept the boxes in my cupboards English side out. Now I keep them French side out because it's kind of glamorous and reminds me that I'm in Canada and not some other country.

To get cosmic here very briefly, the French-Canadian version of the French language is what you'd get if you took a band of village folk from the seventeenth-century Norman coast and stranded them on an asteroid for five centuries. Quirks ensue. Just look at Australia and its English. I think it's the same deal. And ask the Québécois about their swear words—they're *very* strange, and I'm not going to say much beyond that.

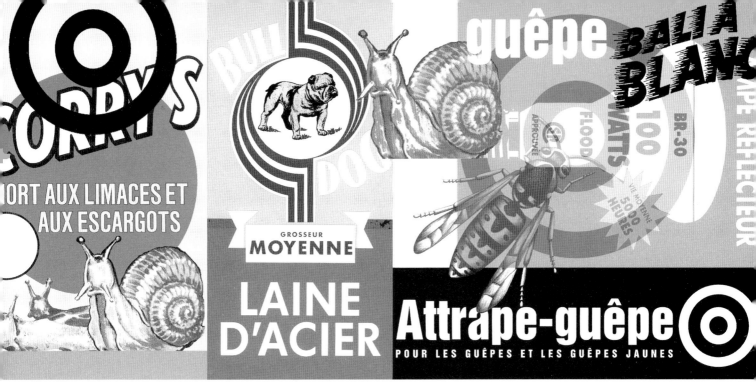

Punchline: as it turns out, three years of Canadian high-school French prepares you for not much of anything except shopping in grocery stores and giving taxi directions; occasionally, you may be able to understand an abnormally sophisticated one-panel cartoon in the *New Yorker*. The keeners will object, but then I was a keener, too. Also, the squandering of human energy, time and money that is bilingual education *does* give a person an excellent secret language to use in front of Americans.

Yes, most Canadians have a complicated relationship with "the other official language," be it French or English. This is because the other language has no real use in their daily lives and only ever seems to create problems, never solutions. But from a historical point of view, bilingualism wasn't really about Mom and Dad or Boss and Employee swapping quips from Tintin and Monty Python. It was a grander strategy for keeping the nation stitched together, but I'm not sure if this was intentional or accidental. In 1985 when Coca-Cola changed the formula of Coke, the whole planet went nuts, and they soon recanted and introduced Coke Classic. When somebody asked if this all wasn't just some smooth marketing ploy, Coke said, "Well, we're not that smart, and we're not that stupid." The same might apply to bilingualism in Canada.

Having said this, all of the separatist dramas of the past few decades have had the effect of generating a wholly Canadian emotional experience that is largely untranslatable to outsiders of any language. It's become one of the imponderables that bind us. Your siblings may drive you nuts, but blood is surely thicker than water. Without bilingualism, Canada probably would have fractured years ago, and a map of North America might look very different now.

Pages 46/47: Canada Picture No. 4, 2001

 12oz. **$1.55**

 22oz. **$2.75**

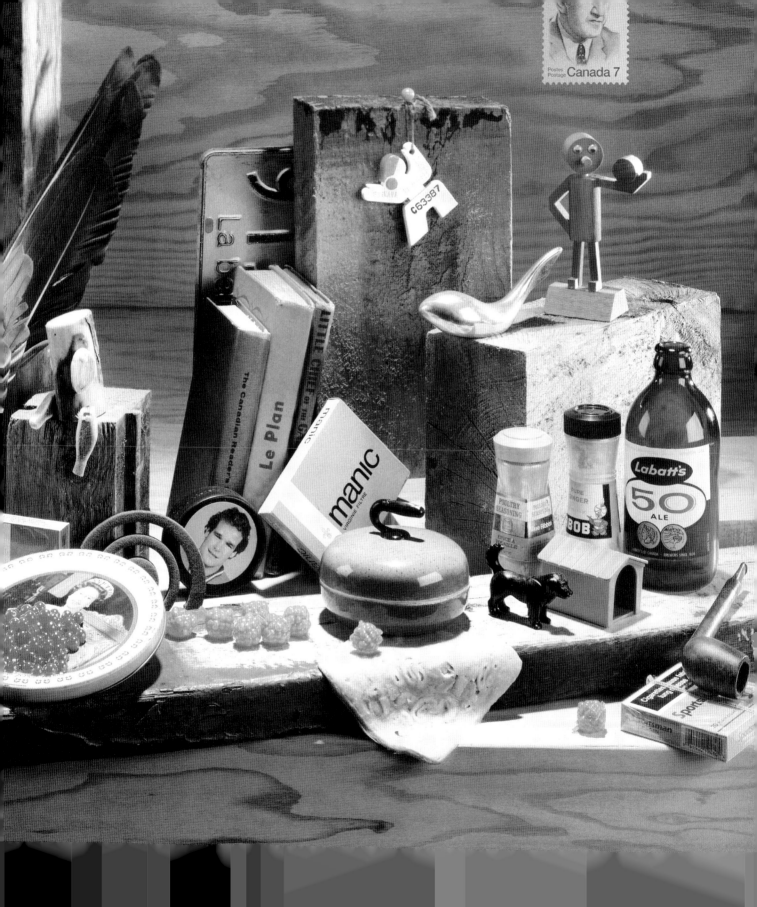

Group of Seven

Canada officially became a country at roughly the same time that the camera became a consumer item. Thus, the Canadian landscape is richly photo-documented. But the late nineteenth-century triumph of the camera also caused a crisis in the art world that continues to this day. Painters, released from the burden of faithful rendering, were creatively liberated. They quickly devised new ways to view the world—Impressionism and cubism and surrealism being the three that most people are familiar with. Cubism and surrealism had little or no effect on Canadian landscape painting, while Impressionism did … but only slightly. Dots and washes of colour were great for evoking the mood of the European garden or Parisian picnics, but when it came to a landscape as raw and cataclysmic as Canada's, Impressionism was simply not up to the task.

In the 1920s a group of young painters set out across the Canadian wilderness, quite literally in canoes, hiking boots and snowshoes, in an attempt to create a form of painterly gesture worthy and capable of evoking Canada's rugged and often brutal wonder. These men were the Group of Seven (although a few others were their equals, and some were not men). With an elemental intensity not found in European or even American painting, they brought Canada alive. They developed a set of lush, forceful painted gestures new to the world. It is possibly the one truly Canadian painting style, and their works are the nation's jewels.

After writing the above words, I sat here at my desk quite drained. And then I had this flash … this *moment* … that lasted maybe two minutes. I'd been thinking about the Canadian landscape, and then suddenly—*craaaack!*—in my head I was racing across Canada at a thousand kilometres a second: over the mountains that made the pioneers despair, across the prairies that will remain flat until our sun goes supernova, over the rock and roots of Ontario and Quebec—and then down into the lunar gorges of Newfoundland. My arms flew up to my sides as though they were trying to get as far away from my body as possible, and my breathing grew short—I was unable to move and saw a lucid flashing sequence of my life in this country: the weather, the soil, the plant life and animals. My upper body stretched upward as though drawn by a magnet, and my eyeballs got hot and began to tear. I was connecting with something vast—connecting with all the people with whom I've ever shared the land.

After the visitation (for lack of a better word) had passed, I sat here at my desk, not knowing what to make of it. So I phoned my mother. She once believed in the supernatural, but I'd always thought she'd surrendered her dreams of messages years ago. When I told her what had just happened, she admitted that she still believed in the profound, too, but she also said

J.E.H. MacDonald painter/peintre 1873-1932

Canada 15

1871-1945 EMILY CARR painter/peintre

Canada 6

that it got somehow harder with the years. She was speaking on a cell phone, and while audible, her voice came through sounding slightly processed—like these old reel-to-reel tapes she had of her parents sending tape-recorded letters to her when our family was stationed in Germany. We started talking about summer, and my mother remembered that her own mother used to take her and her sisters to Lake Winnipeg each August, and that at the end of the day she'd peel off their sunburned skin. "But the sun was different back then. We didn't have lotions or anything, but they weren't as necessary. It wasn't the same sun."

When I hung up the phone, it rang, and it was my nephew who'd just learned my phone number. He's five. I'd given him a bar magnet the day before, and he'd figured out that Canada's two-dollar coins are magnetic, so I promised that we'd go to the beach beside the Pacific and that I'd hide coins, and if he found them he could keep them.

And that was that. Whatever it was, it had passed.

Does this sound nuts? How could it not? But it was real. I think we all have moments like this—*the peace that passeth all understanding*—and they do get fewer and more far between as we grow older. And that's why we have painters and all kinds of artists, because through their work, their eyes and souls and understanding, they can animate others long after they themselves are dead and bring to us a sense of intimacy with life that will support us once life begins to fail us.

Page 49, top: Lawren Harris *Island, MacMcallum Lake* 1921 Oil on burlap 76.0 x 96.7 cm, Vancouver Art Gallery 65.23, © Estate of Lawren Harris

Page 49, bottom: A. Y. Jackson *MacIntosh Bay, Lake Athabaska, Saskatchewan* 1957 Oil on canvas 51.3 x 63.8 cm, Vancouver Art Gallery 68.21, © Estate of A. Y. Jackson

...Game Show Host
...Bimbette
...Songbird

One of the really weird things about being Canadian (and it's kind of traitorous to be talking about this) is how awkward we can sometimes be made to feel by the kind of media article that strives to make us feel proud of being Canadian. To do this, these articles trot out a roster of mostly actors and athletes who've done well ... *in the United States*. There's not a whiff of irony. I mean, good for these people for doing well wherever, but even they must feel a bit like ageing East German gymnasts ball-and-chained to the annual May Day parade float.

I think when you discuss Canada and Canadian culture, you have to be practical. Canada's population is about double that of Illinois. Imagine the state of Illinois spending billions of dollars annually to promote a sense of Illinois-osity. It's a hard image to concoct. Does Illinois torture itself about how many famous actors come from Illinois? No. But Canada cares about how many Canadian actors come from Canada. And puppeteers and mimes and scrimshaw carvers and Morris dancers.

Look at Norway with a population one-*seventh* of Canada's. They probably don't spend billions of dollars annually promoting Norway-osity, but then they don't need to, because they're indisputably a country. Canada has to crank out enough Canada-osity to justify our existence as a full-blown country. It's work.

Headlights

We drive with them on during the day. We are vigilant. We are cautious.

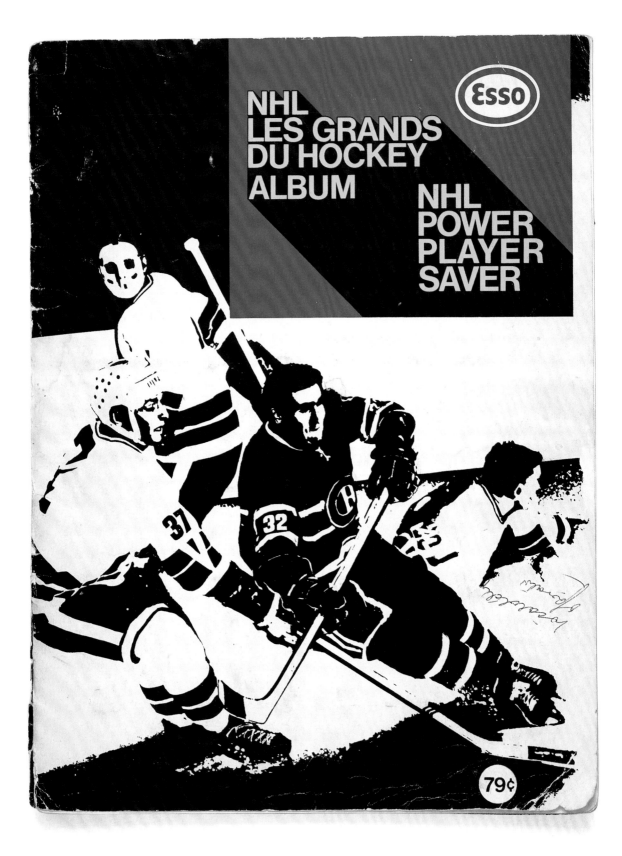

The Legionary

APRIL 1960 NATIONAL MAGAZINE OF THE CANADIAN LEGION NO. 11, VOL. XXXIV

LEGION BONSPIEL AT SUMMERSIDE
(See Page 12)

Circulation Of This Issue: 252,273

Insert this side into recorder ◄ Do not touch the tape inside

Fantastic Hockey Fights
Cat No. 2294 Approx. 30 min.
(IF YOU EXPERIENCE PICTURE PROBLEMS,
ADJUST TRACKING CONTROL.)

Hockey

The thing about hockey in Canada as opposed to hockey in other countries is that the sport percolates far deeper into our national soil and thus affects everything that grows in it. For instance, take my mother the hothouse flower. She visited my studio when a table hockey game was being prepped for a photo that appears in this book.

"Ooh! Table hockey—we used to have one just like that growing up."

"No way, really?" (Two sisters, no brothers—Winnipeg, circa 1948.)

"Oh yes. We'd put it on the dining room table and play it all winter. My sisters and I had such fun."

"You and your sisters played table hockey?"

"We loved it."

Last week my father was discussing a Russian player who'd sat out a year and as a result ended up being able to earn a salary in the tens of millions. I said it reminded me of a player who'd done something similar years before, but my mother by the sink cut in, "Oh no—that chap never made the big bucks. *He'd been concussed too often.*" This, from a woman who has honestly never watched a game of hockey in her life. How did she know about the overly concussed draft pick?

It's in the water.

My father and brother are into hockey pools in a big way. My brother is always "the admin guy," and over two decades has nursed the pools through the days of paper and pencil, into the world of Excel spreadsheets (which handle pools nicely) and then onto the Internet. My dad has won big a few times, but my brother says this is because he always chooses the underdogs, and sometimes the underdogs make the playoffs, and once a team makes the playoffs it gets hot and takes off—which to me still seems like a perfectly reasonable way to win. To beginners, my brother offers the following advice: a) don't choose rookies, b) try not to draft with your heart [i.e., don't choose only Canadians or only Pisces or only lefties or whatever your category—you have to be Darwinian in your choices] and c) don't drink during the selection process.

My other brother enjoys the fighting aspect of hockey games, and nothing puts a smile on his face faster than a VHS tape of *Best of Hockey Fights VII*. As an old boss of mine said, "A good rink is a red rink." Everyone fondly remembers the goalie who severed his artery on a goal post, lawn-sprinkling blood about the rink; the resulting ice posed a great challenge to the Zamboni operator.

Canadian winters are long. Life is hard and so is ice. Canadian teams playing within the NHL are, in effect, a microcosm of Canada's ongoing process of trying to remain a country—battling constantly not only against Americans but against other teams from within their own country. It's ugly and yet it's civil; and most tellingly, it's the one place where people still sing the national anthem.

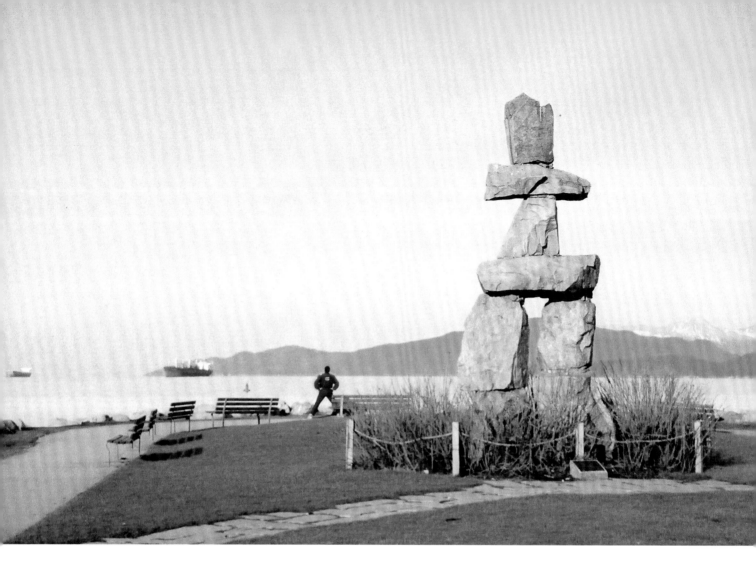

EXPLORE CANADA'S ARCTIC
000
NUNAVUT

Inuksuit

In the early 1990s, a stone human-shaped form, about five men high, appeared along the promenade on Vancouver's English Bay. It was an *inuksuk* (plural: *inuksuit*), a communication and art form originated by the Inuit in Canada's far north. Inuksuit are made of rocks that are piled into various types of cairns, frequently human-shaped. They have existed in the north for several thousand years, but in southern Canada, the inuksuk was this sensational new thing that seemingly entered the culture overnight. Inuksuit instantly joined totem poles in the common imagination as a popularized First Nation form emblematic of Canada.

Inuksuit can work as guideposts, as scarecrows, as decoys, as markers of sacred or dangerous spaces, as well as indicators to show where food is stored. My neighbour has a three-foot-high inuksuk in his front yard. Kids at the beach build them for fun, and they now appear on Canada's coins.

Invasion

If human history has taught us anything, it is that, in the end, everybody invades everybody. And one day Canada will be invaded. If not next year, then in the year 23884, but it *will* be invaded. We simply might not be here to watch the first volley of lasers.

From a military standpoint, Canada is succulently invadable: untold millions of square kilometres of land defended by the armed forces of a peace-loving nation with a population about the same as that of California. *Theoretically,* if Canada is invaded, the United States will come to our aid, but then what if it's the U.S. doing the invading? Well, that's hardly a new thought, and long ago the Americans *did* invade us, but obviously they gain something by not invading us *now*. What might that be? Hard to tell. Canada was always selling grain to the Soviets in the 1970s, and I've often wondered if there was a bit of U.S. jiggling in there—grain traded for spies traded for a truck plant expansion in Oshawa. That kind of thing. In a similar vein, Canada never cut ties with Cuba, making us a convenient back door for American-Cuban activities of whatever nature. And for what it's worth, I've always had a hunch that members of witness relocation plans end up in Winnipeg, not Seattle or Portland, as they always seem to do in movies.

Every year I think most Canadians have a few butterfly-in-the-stomach moments as they picture in their heads the day of invasion. Maybe it will be the Americans. Maybe it will be the Chinese, a thousand freighters full of soldiers beach-heading on the northern coast of British Columbia. Maybe it will be thousands of Danes in brightly coloured, affordable sailboats, attacking Halifax. Or the Russians blitzkrieging the empty wastes of the Yukon. But we *all* know the sensation of vulnerability and of how sickening it might feel to be imperialized. Some people become foamingly, terrifyingly angry when the butterfly feeling arrives—we've met them at parties—and it's when I see people getting this upset that I wonder if that's how the First Nations people must have felt once it dawned on them that the European visitation was, in fact, an invasion.

The Confederation Bridge from New Brunswick to Prince Edward Island is at 12.9 kilometres (8 miles) the longest over ice-covered waters in the world, with two lanes of traffic twenty-four hours a day. Crossing toll per car as of publication: $37.75 (round trip). Meanwhile, Vancouver is desperate for new bridges and tunnels. Good luck :)

the Kitty

Here's a secret: it drives me almost insane when I see Prince Edward Island, a province with the same population as my particular Vancouver suburb, get a billion-dollar bridge connecting their island to the mainland—a bridge they didn't even particularly *want,* mind you—while Vancouver is in desperate need of new bridges and tunnels, and not a federal cent comes this way. And doubtless Prince Edward Islanders go crazy when they see some other place in Canada get some other kind of windfall courtesy of the tax kitty.

As with any country, a sort of high school football team rivalry exists between Canada's ten provinces and three territories, but the prize at year's end isn't a trophy and a varsity sweater; rather, it's multi-billions of dollars handed out depending on what often seems like drug-induced mood swings on Ottawa's part. And Canadians can be nasty indeed when they think that their tax dollars have gone to pay for some hare-brained pork-barrel make-work scheme 6400 kilometres (3,977 miles) away. Add booze on top of the mix, and you've got a rebellion on your hands.

It's a very different situation than in the United States, where it's hard to imagine Floridians caring a damn if Oregonians get a new freeway interchange. But in Canada, the goodies are carefully counted up and lists are compared, and then it's grudge time. It's like kids squabbling over who gets the last cookie in the jar.

In the entertainment world, the way an agent poaches a client from another agent is to say, "But are you really *happy* with your agent right now?" Happy is a word that means everything and nothing, and nobody's ever really happy, with their agent or otherwise, and so the ruse works.

Similarly, whenever the Canadian government needs to divide the country for short-term political reasons, it has its own variation on the poaching agent's technique. It will ask Newfoundlanders or British Columbians, "Are you happy?" The answer, even during the best of times, is usually *no.* And if they don't say no quickly enough, all the government has to say is, "I hear the people in New Brunswick are very *very* happy" or "I hear that the Manitobans are getting a better deal than you are" or, best of all, "I hear Quebec is really happy with things as they stand."

I once did a radio phone-in show in Toronto where I asked the host what happens when nobody phones in with questions or comments. He replied, "Oh, that's easy. I just say 'What about Quebec, huh?' and the switchboards light right up."

Complicating the matter is that there are some provinces—British Columbia, for example—that really ought to be several provinces, while some, such as tiny underpopulated and

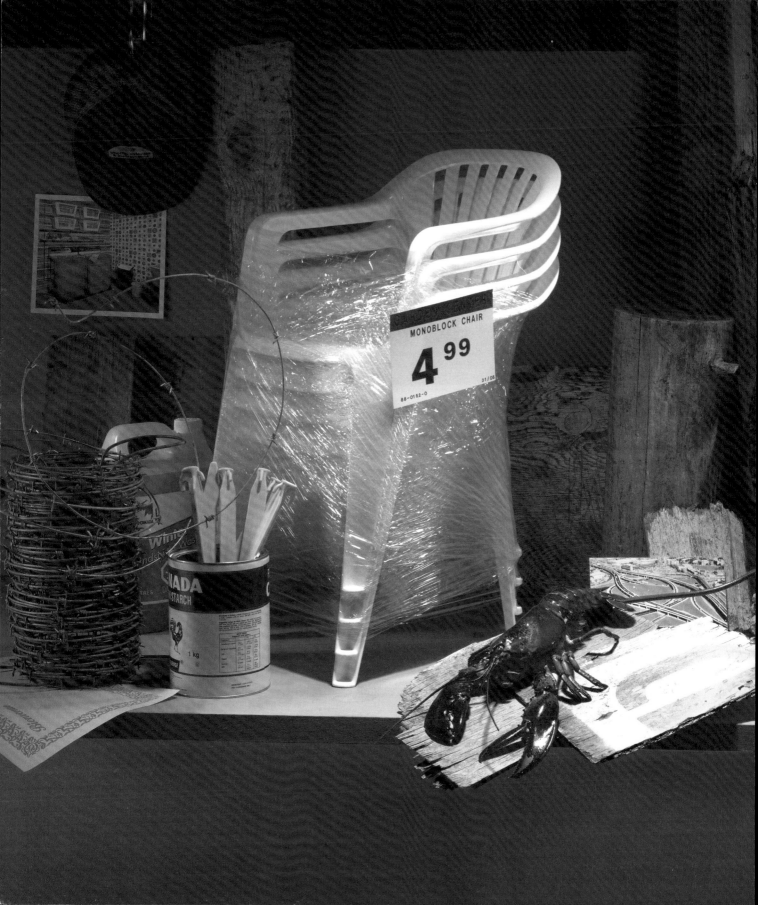

Canada Picture No. 05, 2001

be-bridged Prince Edward Island, got to be a province only because, like its American sister state, Rhode Island, it was there back at the start.

You have to wonder what's really going on, because if the government wanted to, it could quite easily unify the country. Just look at the Americans—a quarter of a billion people who have almost nothing in common except for the fact they've been told they have lots in common.

I suspect that the real issue is not really why Canada can't unify itself more successfully but, rather, *who gains by keeping everybody split apart?* Answer: the Americans and, to some degree, the ruling party, as they can push whatever cliché buttons they need to get or give or hold back whatever they want. Keep everybody slightly divided and slightly conquered. This is an oddly cynical notion for earnest little Canada, but you have to remember that Canada grew up perceiving itself as an uncomplaining inferior place where people could ship their unsold furniture and mistinted cans of paint … and the locals would be honoured to lap them up! The British ran Canada like a pinball machine for a few hundred years, with a contempt and condescension that was at times sickening. The American (I can't believe I'm about to use the following words …) military-industrial complex joined right in. Our trade and labour and political practices are ingrained with this treatment, and have yet, in many places, to awaken from this ancient trance. It's depressing.

Luggage as a grand prize

A powerful memory of growing up for Canadians born before a certain year—say 1970—is of our legacy of bad, *bad* game shows and TV commercials. Bad lighting, bad taped-to-video appearance, bad sound…. The grand prize on these shows was often luggage or a radio—items that were consolation prizes on American game shows.

Badbadbadbadbad.

Around the mid-1980s the shows and ads stopped being bad and rose up a notch to "acceptable." And now they're pretty much like those everywhere on earth, which is kind of sad, too. First, because we still live in a world that feeds on game shows and commercials; and second, because even though they were bad, their badness generated an emotion, and the emotion became a form of cultural glue.

Los Angeles

Canada's fourth-largest city is Los Angeles. More Canadians live there than in Ottawa or Calgary or Edmonton or Winnipeg or Quebec City.

For a hundred years it was push-button simple for Canadians to work illegally in the United States, and vice versa. It wasn't even an issue. These days, if you're a Canadian over the age of twenty who looks even remotely middle class, you'll be fiercely grilled when entering the U.S., more for labour issues than potential terrorism or anything else.

Canadians can obviously "pass for American" as long as we don't accidentally use metric measurements or apologize when hit by a car. Yes, Canadians *could* wrest prized white-collar jobs from Americans. And fair's fair—it's their country and they can do what they want. I wouldn't want Americans coming up here and taking away Canadian white-collar jobs, either. But it's getting very tense, and if they catch you fibbing even once, you're screwed forever on both sides of the border. So be warned.

Of course, the big irony here is that hundreds of millions of dollars' worth of California's film industry has relocated in Vancouver and Toronto, enjoying the fruits of our withering dollar, and our generally wholesome cities that resemble American cities of the 1950s and 1960s. This relocation of the film industry has had the unintended side effect of upping the overall standards of grooming in both cities. I remember once in the early 1990s spending a good deal of time in California. I then had to fly to Toronto on business in the dead of winter. The people waiting outside the luggage carousel in Toronto resembled nothing so much as grizzled, puffy habitués from a Pasternak novel set in frostiest Siberia. No longer! Many Canadians now strive for "a touch of plastic" as much as any industry-savvy game-show host, and this is sort of a loss. The Canadian "look" of yore, while a tad folksy and able to fly under the grooming radar, was sincere. Is the Gap sincere? Is toothpaste that whitens your teeth sincere? Is faking a smile for the camera sincere? Where do you draw the line?

Page 64: Karin Bubaš, *Bedside Table*, from the Leon's Palace Series, 2001.
Page 65: Karin Bubaš, *Kitchen II,* from the Leon's Palace Series, 2001.
 Two still lifes of a different sort: photographer Karin Bubaš was one of a few people with access to a downtown Vancouver crack den from which tenants had been evicted in 1996. The space was essentially a Pompeii-like diorama of life inside that den on the day the police busted it. Mustard inside a squeeze bottle on the kitchen counter had petrified; cosmetics and a child's toys were left exactly where they were when the occupants were taken away.

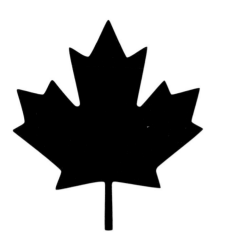

The National Flag of Canada was approved by Parliament in 1964 and proclaimed by Her Majesty Queen Elizabeth II to take effect on February 15, 1965.

When reproducing the flag red at 100% in printed matter, the closest colour from the Pantone colour specifier is Pantone PMS032.

For exterior primary signs a special weather-resistant product has been approved for the red flag in the wordmark. This 3M product is referred to as cast-in "tomato" red vinyl No. 180-13.

The Maple Leaf

In kindergarten in 1967 my class was given red crayons and mimeographed Canadian maple leaf flags, and we were told to colour them in. A flag is a flag is a flag, but what wasn't explained to us kids was that this was a *new* flag, designed, in the Canadian manner, by committee, for the country's centenary. My parents and many of their friends still don't like or trust the "new" flag, and they still believe that the old flag—baronial and ornate, with a Union Jack and lots of doodads—is the real thing.

The maple leaf flag is not an easy one to draw; most Canadians couldn't make a good one if they tried. It becomes easy to envy the flags of Japan or France for their simplicity. And compared to Americans, Canadians don't display the flag nearly as often, but this is changing. A few years ago the only time you ever saw the flag in Canada was on government signage and stationery, in front of public buildings, and once a year for a few days in early July during Canada Day celebrations (July 1). The recent trend of displaying the flag was already in progress when Canada won the 2002 Olympic hockey gold medal. Now every day is July 1. It's kinda great.

As for the way the world sees Canada's flag, anybody who's been to Europe in July or August can attest to the prevalence of Canadian flag patches sewn onto the backpacks of young people. It's more than just an urban legend—it's true. Young people of other nations sew the maple leaf onto their packs; this quickly allows them to dodge the thorny issue of their actual homeland, as Europeans can be quite snippy with, say, *New Zealanders*. For what it's worth, it's always fun to watch movies in which the props department was run by a kid—in the middle of a World War II scene, you'll see the new maple leaf flag and go *Aha!* It's one of those moments where you feel Canadian for real instead of feeling Canadian because someone tells you that's how you're supposed to feel.

Miss Canada

There's a joke that Canadians tell among themselves—certainly never to outsiders. It goes like this … Q: "Why did they make the first runner-up Miss Canada?" … A: "Because the winner already had enough going for her."

The punchline beyond this is that Canada doesn't even have a Miss Canada Pageant any more. It has a variety of *sort-of* pageants, but the original vanished in 1991, and I have yet to hear a whimper. Like most things of this ilk, it was bagged because of dropping ad revenue and shrinking ratings—but, of course, revenues don't fall without a reason, nor do audiences shrink without cause. I think Canadians of most stripes considered the notion of young, rather innocent, girls parading their legs on a ramp in front of a calcified politburo of aging sports figures and local modelling school doyennes, and they concluded that maybe it was best that this type of thing quietly ended.

Which means what, then? Here's a leap: I remember when I was in art school from 1980 to 1984, there began to emerge a strain of artwork done by a certain type of student. It was never very … *good.* The stuff was always a very crack-you-on-the-head image of logging clear-cuts, or of local politicians with Hitler moustaches or [INSERT CAUSE HERE]. What was annoying about this work was that its creators used the underlying political message as an inviolable cloak against criticism on grounds of eloquence, vision, critical thinking or even craftsmanship. *If you dare say anything even remotely negative about my breast-feeding triptychs then you're just as evil as all of* them.

Them was never clearly specified. But it is interesting to note that these students tended not to graduate, and if they did, they left the art world and sought out fresher audiences in other fields. But you know what? That sort of art feels like something that happened so long ago. The biggest worry in art schools these days isn't simplistic politics masquerading as art, it's having enough gigs of memory or upgraded computer hardware. Instead of sculpture and painting, art schools are now broken up into digital and analog. And in many ways, this is the same issue now facing Canadian society. But I'm diverting the conversation here.

The meaning of all of this is that you can't score free Brownie points these days merely by commenting on social inequities—about women or most other previously disenfranchised bodies. Canada has worked harder than any other country to attain true equality for all of its citizens. It's not perfect, but it's the most evolved. Sure, Scandinavia is very socially evolved, too, but then it's also a private club in many ways, with a protective language coating, to boot. Canada and Norway are always duking it out for top spot as the best place to live on the United Nations list, but, I mean, don't bother applying for Norwegian citizenship. Its gates aren't locked but they're not exactly wide open, either.

So yes, there's no more Miss Canada ... *about time*. And the era of scoring points merely for pointing out injustice is, yes, passé. Canada has managed to reach a form of social Valhalla. Good for us. But the moment we rest on our laurels is the moment it all turns to crap. Instantly. Eternal vigilance is indeed the price of liberty.

The future is going to be a very harsh place. It is not going to care too much about equality or fairness. It's going to be mean, and we have to prepare for that. What I find worrisome about contemporary Canada's view of itself is the same thing I find worrisome with (of all things) coffee table books about Canada. They all have lots of glory shots of prairies and rocky coasts and fishing boats and all of that, accompanied by mini-biographies of colourful Canadians of yore—and then at the end they crap out with photos of eight multiracial children dancing around a totem pole, or something equally self-congratulatory—and they seem unconcerned about how gruesome the twenty-first century is going to be. It's going to be *awful*. We have to prepare.

Miss Canada is gone—it was fun, but it's over. At the same time, I have yet to meet a woman my age or younger who ever felt she couldn't be something simply because she had two X-chromosomes. Doubtless I've missed a few, but I think equality is more entrenched and more natural in Canada than in most other places. Even two of our astronauts are female. I remember seeing *Planet of the Apes* in the 1970s. One of the original astronauts who crashed in that movie was a woman. American women I've pointed this out to found the female astronaut a shocking and radicalizing image; Canadian women saw it only as business as usual. Don't feel too warm and fuzzy about this, though—feel thankful and work harder.

Chris Gergley, 1999. This photo appeared in the January/February 2000 issue of *Vancouver* magazine with the caption: "Ashley's on the late shift, so Chelsea's going to the Stones concert on her own."

Maple-Walnut Ice Cream

My family was a no-sugar family—my father earned his dental degree before getting his M.D.—and besides, "If you want something sweet, there's a tub of maple-walnut ice cream in the freezer."

Gag.

Maple-walnut ice cream might have been invented by the devil himself, but, in truth, its creation was more prosaic. For hundreds of years, if you wanted something sweet and lived in Britain's North American land holdings, maple syrup and maple sugar were the handiest games going. Sugar was expensive and came from afar.

I think that maple, as a flavour, is something you bond with as a child or never bond with at all. In retrospect, it's lovely to think of my father as a child in Ottawa looking forward to maple-walnut ice cream as a summer's day treat—it was a national tradition quietly being passed along. But if, like me, you were born later in the twentieth century, maple had a pretty hard time competing with chocolate, grape, orange, cherry and, more recently, mango and tangy algae.

I have a number of species of Japanese split-leaf maples growing in my yard in Vancouver, as well as some indigenous acid-green vine maples. It's pretty hard to imagine going out in January and tapping the ornamental weeping maple beside the bamboo clump for its sap. Or even the vine maple. A genuine big-ass maple tree grows in my parents' yard, with leaves the colour of oxblood that are bigger than your hands. *That's* a maple.

Most people who move to Vancouver from the east miss the fall colours of the maples dreadfully—the sugary smell and the fiery display of emotion they collectively generate. It's a beautiful thing. Everybody on earth should experience it. In Vancouver, we get the April and May blossoms and rhododendrons—equally stunning, but not maple-tastic.

Anyway, if the maple leaf is Canada's national emblem, then maple sap and its syrup constitute our symbolic blood. You eat it at breakfast along with our national sacred starch disc, the pancake. It's not religious, but it's definitely symbolic, and don't be fooled by craftily labelled "breakfast syrups"—demand the real thing.

Money

When I was growing up, the Canadian dollar was at par with the American dollar, sometimes even higher. The highest I remember ever seeing was $1.15 in a McDonald's around 1976. At least that's what I remember. Since then, our dollar has had a long, miserable decline versus its U.S. counterpart. The big dirty secret about Canadians and the Canadian dollar is that we get a gruesome pleasure out of watching it dwindle each year, and every time it hits a new low, we're both proud of setting a record and depressed because it's, well, *sinking.* It's sort of the opposite of the nations that take fierce pride in the strength of their currencies.

Canada and the United States are each other's largest trading partners, and while I'm not given to conspiracy theories in general, I can't help but wonder if the Americans quite cynically bleed the Canadian dollar in some unspecified manner every time they need to balance their own books. In my head, I'm seeing a room deep within the U.S. Treasury Building, where some guy says to another, "Well, Norm—looks like we're going to have to tap some maple syrup this month."

Compounding the oddness of the ever-shrinking dollar is the government's continued assurance that there's nothing to worry about and that (this is so sick) the shrinking dollar is *good* for us, because it allows us to slut away our natural resources at discount prices.

The unfortunate end point to the shrinking dollar is that it can only go so far before it dies and we end up adopting American currency as our own. And doubtless we'll be told this is good for us, too.

On a practical level, instead of the dollar bill, Canadians use the loonie, an eleven-sided large-ish coin, quite heavy and not unattractive. It took a good decade for me to get used to saying, "Could you change this loonie for me?" without feeling like a cretin. But once I finally got used to saying the word, the much-beloved two-dollar bill was then replaced by the toonie. Oh God, an even larger coin, bronze in the middle, nickel on the perimeter.

At the end of a few days, when Canadians clean out their pockets, it's like travelling in Europe, where you can have a barbell's worth of coins stashed away—it's heavy. Years ago, pocket change never amounted to very much, but now it adds up quickly; finding that you have ten dollars in change is not uncommon. But, of course, that's in *Canadian* dollars.

Oh, and if you take a black Sharpie pen to the portrait of Wilfred Laurier on the five-dollar bill, he looks just like Spock from *Star Trek*.

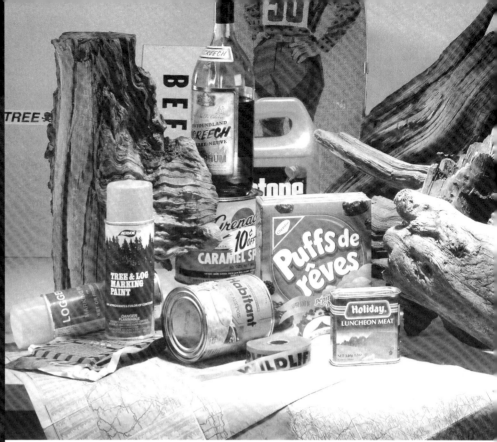

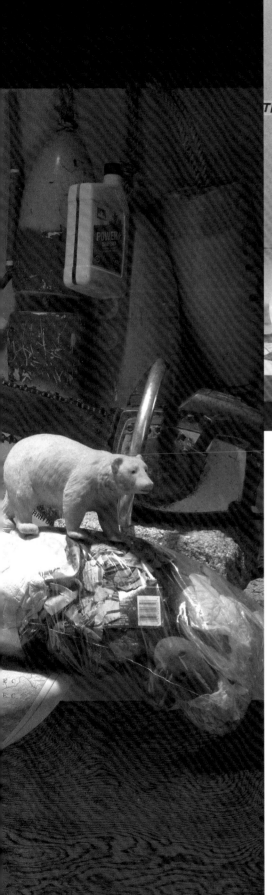

Left: Canada Picture No. 06, 2001

Right: Canada Picture No. 11, B+W detail, 2001

Newfoundland*

In high school, we had to read a science-fiction book called *The Chrysalids.* It's set in a post-nuclear future where only the people of Labrador have survived massive atomic warfare in the southern part of the continent. If boats travelled too far south, the barnacles fell from their hulls, and the isolation of the place proved to be its salvation. In reality, the isolation of Labrador and Newfoundland, coupled with the long winters and the region's fiercely held Scots/Irish history (Newfoundland is where Europeans first touched base in the 1500s), has created a population of creative and quirky souls. They speak in a dialect that can rival Navajo for indecipherability—that is, when they really ham it up—and I think only Newfoundland can rival Quebec for the title of "most colourful province"—as well as being the region that most lives up to Hollywood's central-casting vision of what Canada and Canadians are supposed to be like: lumberjack plaids, salt-encrusted yellow rain gear …

Newfoundland is like the Hawaii or Alaska of Canada, as it became a province only late in the game, in 1949. My parents still think of it as another country, the way I still don't believe temperatures given in Celsius. It has its own time zone, one and a half hours ahead of Toronto and New York. It's a cold and gorgeous rock and, like many northern places on earth, isn't particularly suited for large numbers of carnivore primates to eke out an existence. From the rivers of Labrador come electricity; from its rocks come some minerals. From the ocean off Grand Banks comes (until recently) cod. And there's also some oil, but it's jeezly hard to reach … and that's the lion's share of Newfoundland's economy—but a place is more than merely its economy, just as Canada is more than a set of borders and a collection of special interest groups.

When I was younger, it used to really drive me nuts that the Maritimes were always being subsidized, often with schemes everybody knew were flat out make-work, and the funding process couldn't have been more cynical, joyless and sad for everybody involved. On a profound level, nobody truly wants something for nothing. People want and need to contribute, but the pork-barrel tactics of the twentieth century were no way to do it. It's only very recently that I've said to myself, "Good God—what was I thinking?" In Newfoundland and the Maritime provinces rest much of the seat of Canada's soul. Which is priceless. Which sounds so goofy to a previously jaded heart, but so it goes. Of course it's worth paying for, but it ought to be with real work and real ideas, or else it's plain out insulting for everyone involved. My political diatribe ends here.

P.S.: Newfoundland also has this drink, a—how shall I say—extreme rum called Screech. It's the kind of stuff you drink on a dare, but go on, give it a try. And if you hold a lighter up to your breath after drinking it, you'll shoot flames.

*As of October 2001, "Newfoundland and Labrador."

1971

In the mid-1960s and into the 1970s, Canada went "nation-crazy." After a century of fuzzy identity and ambiguous self-esteem, suddenly Canada became full of itself, and the land abounded with Canadian mural painters, Canadian pundits, Canadian TV shows, Canadian pavilion designers, Canadian puppeteers and Canadian mimes. And on and on. There were awards and medals and dinners and think tanks and … well, had this flourishing not happened, the country most likely would have been consumed by the United States, so any nitpicking past this point is just that, nitpicking. The national mania got the job done.

But at the same time, Canadians still live with a fair amount of cultural residue from that period. Ways of viewing Canada that were formulated during the rolling of joints and the knitting of afghans were good for that moment, but they now seem almost poignant and childlike in the face of current global conditions. Multicultural ethnic dancing once a year on July first is not going to keep Prudential-Bache or the Daichi Kangyo Bank from gobbling up our land and short-selling our currency.

And I also think that people forget that all of that '60s and '70s national rah-rah was a hundred per cent government subsidized. A major problem with the *Go Canada!*-style cultural residue is that it makes us think Canadian culture can still happen the way it did back then, except without the money. Cultural nostalgia may merely be financial nostalgia. For the record, I'm totally for massive government arts subsidization—the one major bone of contention between me and my parents—and I also think it's naïve to assume the private sector is able or willing to sustain nation-building on its own. All you end up with is … *beer commercials*—which is fine in its own way—but *only* beer commercials. It takes a ton of rock to find a diamond; so it is with culture. Of course there'll be crap, but there are still those diamonds.

But oh! To look back on clippings about painters and writers in the 1960s and 1970s—the fun they must have been having! It's dizzying to discover the freebies and pork they enjoyed—the banquets and the galas and trips around the world and—it boggles. And you can't begrudge them anything because they *did* help Canada remain a country. That's enough in itself, and everything else is, as said before, nitpicking.

Pages 76/77: Chris Gergley, *Yard at Arcola & Victoria* from the "Queen City" Series, 1998
Page 77: Logo for Canada's Centennial, 1867–1967

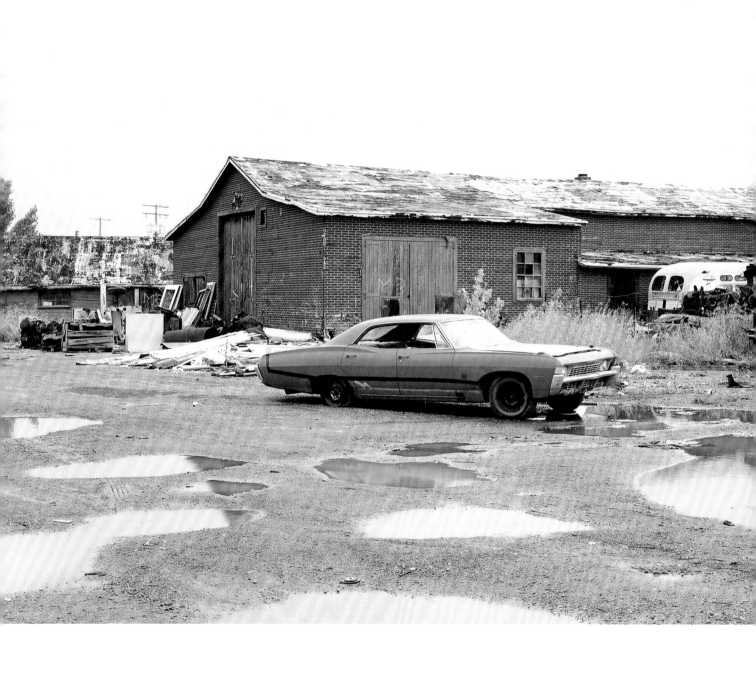

Nowhere = Anywhere

Anybody who's ever visited Japan—or Germany or France, for that matter—knows that when you go into a hardware store there, you'll find a Japanese brand of string (most likely ten different brands), a Japanese brand of sandpaper and a Japanese brand of pencil sharpener. In the grocer's next door, there will be Japanese brands of olive oil, powdered hot chocolate and toilet paper. And so on. What makes Japan so much fun is that it is a complete consumer universe unto itself. It has no need or want of everyday brands from other countries, save for status goods or fresh fruit.

In Canada, when you walk into a store you'll find almost always American brands with a small maple leaf cynically slapped onto the logo, plus, of course, English/French text. It is astonishingly difficult to assemble a pile of purely Canadian goods.

When I was growing up, the American version of any product, cereal for example, was always brighter, more colourful and had better prizes inside. For Canadians, a trip to the border towns of St. Stephen, Burlington, Buffalo, Windsor, Minot or Bellingham often means a broader, funner and shinier shopping experience—if you're into shopping experiences, which most everyday folk are. Even my dad gets a small kick every time he darts over the border for cheaper gas.

But there *is* a dark side to all of this. In 1998 I visited Santiago, Chile. I don't know what I was expecting to find there, but what I *wasn't* prepared for was a drier, sunnier New Jersey. There was nothing for sale in Chile that wasn't made by an American branch plant. Nothing. I couldn't even find postcards, and I *looked,* dammit, I looked. There was a Mail Boxes Etc., a Chevron, a Dunkin' Donuts and … it felt like I was in Irvine, California. Or the outskirts of Fort Lauderdale. Inside the grocery stores were Libby's canned peaches and Campbell's soup. The hardware stores were clones of their Texas brethren. The country had been culturally gutted, and while it's evil to not wish abundance for your fellow man, Santiago had the sci-fi texture of a land where a ghastly price had been extracted in return for effortless plenty. In the case of Chile, I think it was its sense of itself, which is just plain sad.

Canada has avoided Chile-ization, but only just. Having said this, I doubt many Chileans going from Chicago to Toronto would notice a glaring difference. The differences are subtle, and not necessarily played out in the consumer arena. But there is something deeply wrong with a place where nothing for sale is *from* there. It just is, and anything that can be done to prevent this sort of corrosive colonization is not a bad thing.

One Billion Years

In January of 1965, a slide of millions of tons of rock fell onto a stretch of the Trans-Canada Highway just east of the British Columbia town of Hope. It covered an area the size of a medium-sized city 85 metres (280 feet) deep and buried 3 kilometres (2 miles) of the highway. Five years later, while on a hunting trip with my father, we circumvented the slide on the new road built around the bottom perimeter, and I remember asking him, "Were there people on the highway?"

"Yes."

"And were they buried?"

"Yes."

"And were they ever found?"

"No. Not all of them."

"Is anybody going to try?"

"No. They're basically inside the mountain now."

So in my head there are these people who've been trapped inside crushed campers or Cutlasses or Volkswagens—in my mind it's a vast parking lot of vehicles, even though the real number was four. These people will remain crushed inside those vehicles, in all probability (in a very scientific sense of the term) until the end of time.

I remember that when Mount St. Helens erupted in 1980, what was so weird about the event wasn't so much that a volcano erupted but, rather, that a volcano erupted *while human beings were around to see and record it.* As with the Hope Slide, it's rare to have geological time and human time overlap so neatly.

Geological time is something Canadians have learned to confront more aggressively than most other countries. Other countries have volcanoes and earthquakes, which are, in one sense, brief Earth pimples. Here, geological time works the other way. In Canada, time has been around forever. Canadians fly over the land and see lakes scoured into its surface by countless ice ages and granite tongues of lava left over from the birth of the world. Canadians fly over the Rockies and see a billion years of time crystallized then smashed to form jagged mountains. A friend of our family runs a ranch in Alberta, and when he tills his fields, dinosaur bones come up with the plow blades. Europe may have castles and China may have the Great Wall, but Canada has all this evidence of raw bulk time—time before history, time before life itself. The scale of geological time's sweep across the nation is so vast and unremitting that it can really render human time depressingly minute in comparison.

Pages 80/81: Roberta Bondar, *Granite island in the middle of Beausoleil Island's Fairy Lake, Georgian Bay Islands National Park, Ontario*

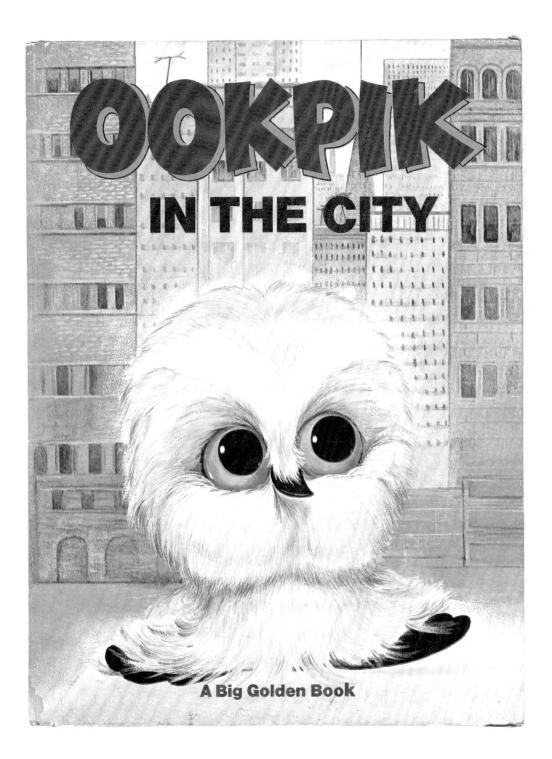

OOKPIK
IN THE CITY

A Big Golden Book

I sometimes wonder what thoughts must have passed through the heads of early European settlers when they confronted this new landscape. More likely than not, they were fleeing their own homeland's social history. Maybe they thought they'd escaped history once and for all by coming to a world they thought was brand new, only to arrive and find that the New World was actually far older than anything they could have ever bargained for back home.

And I also wonder what the Canadian landscape will look like in a billion years. People will be long gone by then. Life, too, I suspect. Most every human trace will have been crushed or eroded—cities and canals and every coffin on the planet. But those skeletons inside their Volkswagens or Cutlasses or camper vans at the Hope Slide will still be there, exactly where they are right now. They bind us to the future. They're time made frozen.

Ookpik

Ookpiks are stylized owls made of sealskin. They were invented in the early 1960s and hand-made in the Inuit village of Kuujjuaq (formerly Fort Chimo), Quebec. They're slightly silly looking, but they're oddly wise, too, and many Canadians will melt before you at the sight of one. I used to have an Ookpik, but it made the grand sacrifice as dinner for our lab, Ranger. Ookpiks even had their own series of children's books, and for a few years they were adopted by the government as a Canadian trade fair symbol and then one day they simply … *vanished*. Where? Why?

Ookpiks pop up very rarely in antique shops or on Internet flea markets like eBay, but they have the same cachet of extinct species such as the Labrador Duck or the Great Auk. Alas, they burned too brightly too quickly, and paid the price.

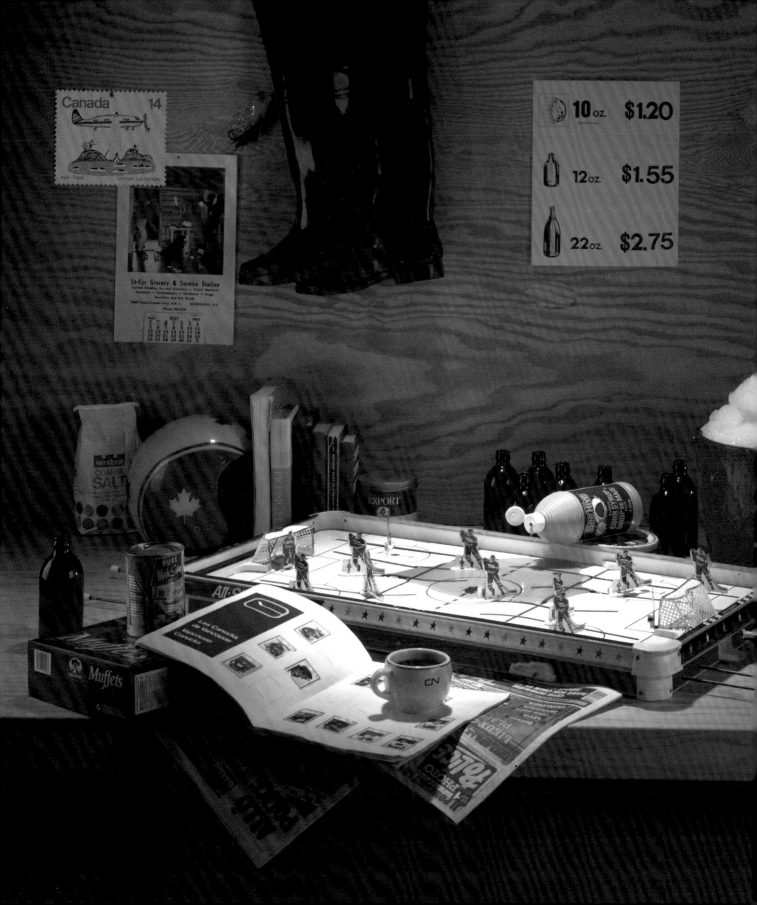

Piss

There are few, if any, Canadian men who have never spelled their name in a snowbank.

Vinegar

A few summers ago, the woman who sweeps up hair in the place where I get mine cut—a feisty Glaswegian war bride—told me about her ritual Friday afternoon treat—a sandwich made of white bread, margarine and ground up salt-and-vinegar potato chips. After concealing my initial gag reflex, I wondered, *hmmmmmmm*. That night, I had a large group of people over for an outdoor dinner, so for hors d'oeuvres I passed around a platter of S&V sandwiches. For the next week I went around the yard finding partially nibbled bread triangles concealed in the most clever nooks and crannies.

Canada's love affair with white vinegar is a social by-product of the country's British roots. Vinegar cruets appear on cafeteria and diner tables across the nation, and vinegar is sprinkled almost exclusively on french fries. If no fries are available, salt & vinegar–flavoured potato chips will suffice. Or sandwiches, maybe.

Poutine

Canada has no national foods which are, to have them described, frightening —for example, the Scots have haggis, and the Arabs have sheep's eyeball soup. But Canada *does* have *poutine:* french fries covered with melted cheese curds, which are then glazed with gravy. Poutine doesn't have the immediate fear factor of haggis, but you *do* have to steel yourself for the first few bites. Having said this, poutine's rich content of starch, sugar, oil, fat and salt are ideal for larding it up for a dark Quebec winter. Western Canada, which was once thought to be poutine-proof, is now coming to embrace the dish. Next stop: the *world*.

Pages 84/85: Canada Picture No. 07, 2001
Page 88: Canada Picture No. 08, 2002
Page 89: Canada Picture No. 09, 2001

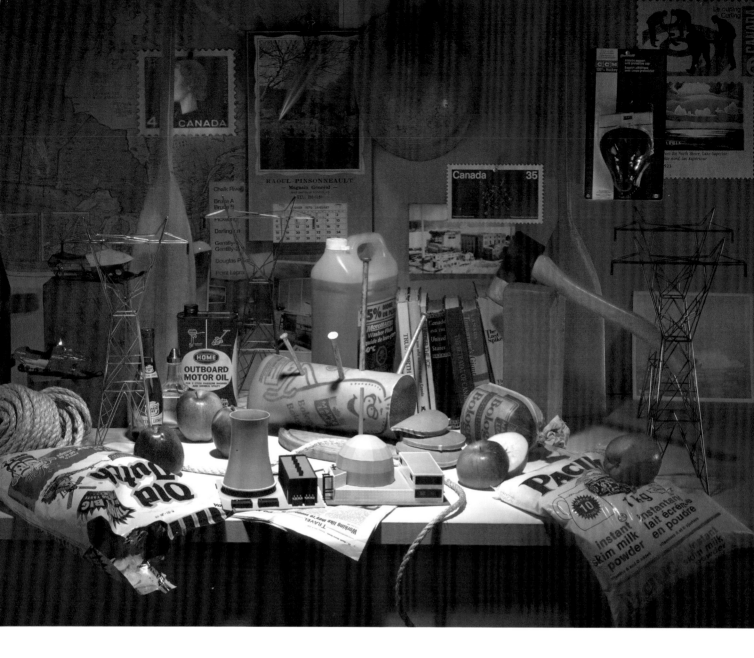

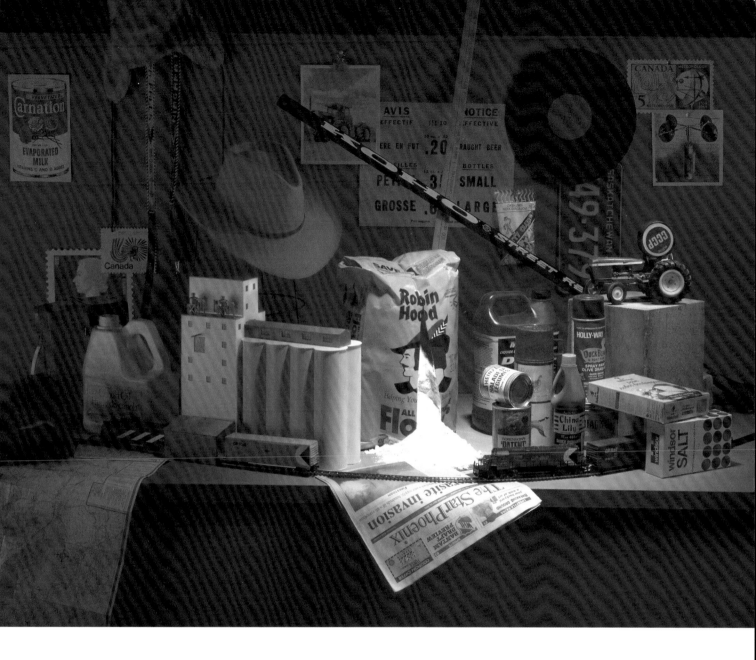

Power Broker

I have a friend who is a power broker in the most literal of senses. He works in a downtown Vancouver operations room covered in maps and charts and screens, like something out of a NORAD command centre buried beneath North Dakota. His job is to notice, say, that it rained a centimetre (1/2 inch) in northwestern Quebec, and then use that information to calculate how much extra power can be generated as a result—and then to figure out the best price for it throughout the continent's energy grid. A heat wave in Nevada means more power will be needed for air conditioners. An arctic front in Manitoba pushes up the need for heating energy. A holiday in the United States means less overall need.

In Canada we live with this literal sense of power. Inside our heads we figure that, no matter what, there'll always be tons of free and renewable energy—particularly in British Columbia, Ontario and Quebec.

Having said that, I have a friend in Los Angeles who bought a plug-in electric car a few years ago. Throughout town, she was the centre of attention ... a friend of the planet! At Mr. Chow's in Westwood, we got to park right at the front door in a special "Friend-of-the-Planet" stall, complete with an electrical outlet and located even closer to the front door than the handicapped parking spots.

A year later, Angelinos driving that same model of car were vermin. Rolling electrical blackouts and bankrupted utilities had changed the state's views on energy. Other drivers now threw chewing gum onto the car's side panels, baking pimples onto its finish; on Interstate-10, a balled-up used Huggie was lobbed through the car's open window. And then a year after that, electricity was cheap again, and once more she was a friend of the planet.

Moral? Americans want and need energy. Badly. And for the first time in years, Americans have remembered that: a) Canada exists, and, b) it has energy worth having, and then c) not only can they take the electricity, but they might as well take the water while they're at it.

Most Canadians, left or right, have a deep distrust of recent trade agreements when it comes to energy and water. Americans, while not the best conservationists, *are* long-term planners. They plan for decades, if not centuries, down the road—for example, the recent decommissioning of sea-level military bases, in expectation of rising ocean levels. Canada only ever seems to plan for months ahead.

Electricity, and even more importantly, *water,* are possibly the only issues on which nearly all Canadians stand united. There's something sacred about them that just can't be messed with, and when there's news of drought or power shortages in the papers, the Canadian instinct is always to make sure that the government isn't bending over on this one issue. Heaven help the government that sells us out.

Railway

In the fall of 1988 I had to move to Toronto for a job. That same month, VIA Rail, the country's nationalized railway service, was announcing plans to shelve the cross-country run. Swine! I decided to take the train rather than fly, to bond with my country on this one final gasp of a bygone era.

I expected to find a train filled with compatriots, hearts aflutter with thoughts of their noble voyage. Wrong. All I found were chain smokers who, between puffs, discussed their fear of flying and swapped tales of muscle relaxants, sedatives and hypnotics. They drove me crazy, and I remember escaping them and going to the antique oval-shaped bar car at the end of the train, then standing at this little railing and watching the sun set blood red where the receding tracks met the horizon; that's all I needed, really, to make me feel the trip was worth it. It was easy to imagine the ghosts of passengers of yore—my family mostly: my father crossing the country in WWII, wondering if he'd serve overseas, and my mother and her family leaving the Winnipeg floods of 1950 to stay with relatives in Regina, wondering if they'd have a home when they returned. I saw visions of my grandparents pulling up stakes and taking their Bibles and pianos back and forth across the flatness. And, of course, I had visions of the pioneers and locusts and bison and 1930s gangsters—all of these memories melted onto these two strips of metal, like butter into a slice of toast. I thought of the ice age's retreat and of vast underground lakes beneath the prairie surface. I remembered, from what little history we *did* study in school, that Canada could never have happened at all without a railway—that the railway was actually this wacky scheme meant to forestall the United States from annexing the west, and it turned out to be not so wacky after all.

The memories and ghosts continued—1950s lakes brimming with the polio virus; the dust bowl of the 1930s; cowboys and Indians both real and fake, both enemies and allies; migrating chevrons of mallard ducks and trumpeter swans; high school greaseballs drag racing Barracudas on the outskirts of town; every small town with exactly one Chinese restaurant. And then I suppose I melted into the train tracks, too, at one moment becoming part of the road and part of the journey, while the prairies continued unfolding and unfolding as I went to bed, and when I woke up the next morning, they were still unfolding—and they're still unfolding even as you read this, for someone else is making that exact same trek across the land.

Pages 92/93: Karin Bubaš, *Den of Dr. Douglas C. T. Coupland,* 2001

Reserves

In 1983 I studied sculpture in Sapporo, Japan—up on Hokkaido, the large island in the country's north. It was my first trip to Japan, and I'd been expecting a Technicolor IMAX Dolby kabuki dreamscape—instead, I found a place nearly identical to British Columbia. Hokkaido and B.C. were both developed in the Western industrial mode at roughly the same time in the nineteenth century and share a similar landscape, weather and a whiff of the Klondike.

I quickly learned that in Hokkaido's tourist shops, you don't find Japanese folk art; instead you find trinkets ornamented with the motifs of the Ainu (pronounced *eye-noo*) people, a race indigenous to the island. The Ainu are an anthropological riddle, as they're Caucasian, and nobody's really sure when or how they ended up in Japan in the first place. I became interested in the Ainu and wanted to visit what you might call "Ainu World"—a small tourist-trappy place surrounded by tall wooden poles like so many huge sharpened pencils bundled together. It was difficult getting someone to take me to Ainu World. Everybody I asked about it said either "Why would you want to go there?" or "It's kind of ... depressing."

In the end I bent someone to my will, and we visited Ainu World on a November Tuesday afternoon. The parking lot was deserted, and when we looked in through the front gate, the place looked like one of those photos of abandoned children's playgrounds in downtown Chernobyl. There was also litter on the ground—the only litter I've seen in Japan on my many visits.

We assumed the place was closed, but there was a cashier in a little cubicle, so we bought tickets. My escort mentioned that the park looked a bit ... bleak, and asked if everything was okay. The answer she got was, "Oh—yesterday the Ainu all flew down to Tokyo to go shopping, and they're not back yet."

Oh—yesterday the Ainu all flew down to Tokyo to go shopping, and they're not back yet.

To this day, it still hasn't quite settled in my mind—the image of an entire race of human beings on an Airbus 340 flying south in pursuit of fun nightclubs and cheaper luxury goods. Imagine all the Maoris on earth on a 747 headed to Las Vegas, or all of the Zulus on a charter to Euro Disney. Even harder to imagine is how an entire race of people can be numerically reduced to fill a single charter flight. Well, several charter flights. The Ainu population is now under 25,000 compared with Japan's 127,000,000. Their language is on the brink of extinction. They'll be gone soon.

Another anecdote: the following year, back in Vancouver, I landed a summer job helping to prepare the props for the Pope's Vancouver visit. One of my jobs was to design and co-ordinate the coloured flash cards to be used on the south side of BC Place Stadium—like those cards they use in North Korea that everybody holds up so the face of Kim Il Jong Il appears. In my case, one of the stadium's three flash-card designs was to be a First Nations motif. I was told to mock up one quickly for a meeting, so I invented a fake thunderbird-motif flash sequence. The meeting went well, and a week later I was asked to prepare a flash-card sequence using genuine First Nations imagery. So I began to do research and generated designs—designs and designs and more designs, with none of them looking quite *right* to the committee. As the day of the visit neared and the cards had to be purchased and sequenced, it was finally decided to go with the original fake thunderbird sequence because it looked the most "Indian-y."

Let's change gears. Most Canadians know about the "pox blankets." These were blankets infected with smallpox and distributed cheerfully to First Nations tribes in the eighteenth and nineteenth centuries. This was one of the first and deliberate uses of germ warfare with the aim of genocide. While these tales are thought to be urban legend, documents, easily accessed on the Internet, authenticate the process both here in Canada and the United States. These attempts were feeble, small and isolated, but they do help illustrate a larger picture.

Here's something else: on the night of January 28, 2000, a thirty-four-year-old Saskatoon Cree man was found by two policemen, drunk and ambling along a road in the city's west side. The man was handcuffed and driven 6 kilometres (4 miles) away to the edge of the city, not far from the Queen Elizabeth Power Station. In minus 25° Celsius (-13° F) weather, he was tossed outside the car and abandoned there. By a stroke of luck, the man headed toward the power station, rather than downtown, and was able to convince the night guard to phone for a cab. This incident would have gone unreported and unremarked had it not been for a rash of Cree men found frozen to death, often with fresh bruises and cuts, on the outskirts of town.

This process of making First Nations peoples "walk it off" is now under an extraordinarily tense investigation, but Crees remain pessimistic that anything will ever come of it, and why should they? They've had nothing but crap for nearly five hundred years.

There's an Indian reserve on the North Vancouver shoreline just a quick drive from where I grew up and where I now live. It's the Capilano Band's reserve, and I've never once driven into it. We were always told we weren't allowed to go there—that there were money-crazed radar traps there—*your car will be vandalized! They'll stone you!* Basically: DON'T GO IN THERE! Nonetheless, I've driven *around* the reservation and peeked in. The neighbourhood seemed middle class enough, but then odd and disjointed facts became apparent: a front door had no steps leading up to it, so that it opened onto a 4-metre (13-foot) drop; there were no bourgeois attempts at gardening; cars were parked, well, anywhere. There *are* different rules there. The attitude toward land—soil, rocks, trees and space—is fundamentally different.

Canadians in general are silent regarding the relationship between Indians and non-Indians. I've always wondered why they don't teach us in school something simple like, "There's this reserve not far from here, and here are the rules for going (or not going) there." I'd also like to know whether, if a crime is committed against us when we're on a reserve, are we subject to a different court? Do Indians use special passports? Do they pay taxes? Can we even use the word "Indian" any more? Do they have extra rights or fewer rights than non-Indians? Are they Canadians-Lite? Are they Canadians-Plus? Is it racist or boneheaded to ask these questions?

If I were feeling charitable, I might assume that this silence was all some sort of benign legislative oversight. "*Oh—we just assumed that Canadians would figure it out for themselves.*" That kind of thing. But it seems unlikely. In a case like this I always focus with a cynical lens: *Who gains by nobody saying anything?* The First Nations certainly don't gain. As a result of

Pages 96/97: Chris Gergley, *Road shoulder and high voltage tower beside the Queen Elizabeth Power Station, Saskatoon, Saskatchewan,* 2000
In the summer of 2000, photographer Chris Gergley visited the site where, the previous January, two police officers had dropped off a Cree man at the edge of Saskatoon in minus 25°Celsius (-13°F) weather. The man survived and an investigation of the policemen ensued.

a generalized Canadian ignorance about our own relationship with them, Native people are subject to awkward, suspicious, patronizing, blank (or most likely guilty and self-flagellating) treatment from the rest of us. A more awkward social exchange is hard to envision. It's odd because the friction between French- and English-speaking Canadians is frequently defined in terms of whether or not Quebec is distinct enough to go it alone, with the attendant arguments and referendums drawing stalemates. But with First Nations Canadians, there is *no* ambiguity—they *are* different in profound and ancient ways.

So then, *who gains by having average Canadians being kept in the dark about whether or not they can even drive their car onto a reserve without being arrested or detained or fined?* As usual, the government gains. As a tested formula, passive silence is the single most effective tool to ensure that neverending First Nations land and rights negotiations never *do* end. The logic of silence dictates that if the process is kept up long enough, maybe the First Nations people will eventually dwindle down to Ainu World status, fitting into a few charter flights. The Capilano Band has roughly 2,400 members—about five or six 747s' worth. If those planes crashed, the Capilano Band would all be gone. What was their language? What was their culture? How come we never really interacted with them? How did the relationship become so charged and demonized? In any event, the gift shops will continue to sell trinkets and knick-knacks adorned with semblances of Indian art—most likely done by someone like myself who was told to do something "Indian looking."

Page 100: Karin Bubaš, *Hat Collection* from the Florence and George Series, 1998. Hats in the basement of Bubaš's grandparents.
Page 101: Karin Bubaš, *Double Beds and Two Paintings* from the Florence and George Series, 1998. A room in the house of Bubaš's grandparents.

Rapeseed, Zinc & Cod

I've had many jobs, but none as left field as the one in 1985, designing baby cribs in the Vancouver suburb of Richmond. "Factory Tour" is my middle name, and in Vancouver, where almost nothing is actually physically *made,* the daily trip onto the crib factory floor was a joy— it was a complex, noisy scene reminiscent of that cartoon where two chipmunks get locked in a fully automated vegetable canning plant.

My job required some degree of knowledge of a number of skills aside from mere styling: staining, spraying, parts inventorying, the shooting of catalogue photos, safety regulations and, most importantly of all, having to work with whatever wood was both available and cost effective. I'd naively thought that British Columbia, being one of the world's largest wood suppliers, would be drowning in cheap and good wood. Wrong. A fair number of the cribs had to be made from alder, the crabgrass of the tree world—alder that had to be imported from Oregon, to boot, because even B.C. alder was too hard to both find and price, but I'll get back to this shortly.

I think that when you grow up in Canada looking at the maps and charts of the country in social studies textbooks, you learn the pictograms for wheat, ore, lumber and fish very quickly. The abundance and primacy of wheat and spruce and pitchblende help define how Canadians see themselves. Nature's largesse becomes our own largesse. The world has been good to Canada, so Canada would like to be good to the world. I think in many ways this simple equation is true.

Canadian textbooks invariably ring with the bounty of everything mined, harvested and chopped down here. And if Canada's production of a certain mineral like, say, tungsten, isn't the world's largest, textbooks will say, "Future tungsten mines promise to be among the world's richest." And so on. "*Our freighters groan with ore, and our singers sell millions of albums worldwide. Electricity production is up, and zinc smelting grows and grows.*"

I suppose in practice you're always supposed to talk up your nation's economic strong points no matter what, but it gets sticky. Yes, we have a lot of fish and trees and igneous intrusions, but it's not like we actually made them. They were already here. We got lucky, but let's not push it. Some Canadian commodities such as old-growth lumber are vanishing quickly, and cod, after being raked in for hundreds of years, are nearing extinction. But it's hard work to shake the 16-mm industrial film version of Canada's natural resources. We're shown the movies very early in life, and we're shown them often.

The dirty secret of the Canadian economy is that we don't actually *do* anything with what we reap—we ship it somewhere else, and then other people apply brains and intelligence to it and make it something more valuable—and sell it back to us. Fact: Japan doesn't want competition

wheat	mining	unemployment insurance scams
hydroelectricity	pot	fast food
real estate schemes	internet fraud	lumber

making high-cost, high-quality papers. Another fact: North Carolina doesn't want cedar armoires and sleigh beds made in the country next door. A third fact: the game is rigged, and Japan and North Carolina will always get their wishes. It was a lucky afternoon at the crib factory when some Canadian wood made it onto the floor.

I remember in the high school library there were always these scary advertising-free copies of *Soviet Life* magazine from the 1970s. Inside them, rosy-cheeked Svetlanas and studly Yuris smiled from orchard to factory to soul-deadening apartment block—how could anyone possibly be unhappy in a workers' paradise? The difference between "People's Rubber Boot Production Is Up!" and "Saskatchewan Wheat Crop Biggest Yet!" is small.

Relentless boosterism—*Canada, land of bounty!*—pre-emptively short-circuits political dissent. A citizen ungrateful enough to point out the depressing status quo is … *suspicious.* We're a commodity economy; to expect anything more than this is pushy and greedy. Pillageability is one of Canada's key characteristics.

For fifteen years I've thought B.C.'s uselessness in making wood products was insanity, but then, for fifteen years I've been asking the wrong question. The question is *not,* "Why can't we build great wood products here in Canada where people are crying for jobs?" The question is really, "Who *gains* by keeping Canada from making things with its wood?" It sure isn't Canada.

Rye

Until I was twenty-six and toured a Scottish whisky distillery, I thought rye and whisky were the same thing. But they're not: rye is made from rye; whisky is made from malt. Rye is like this drink that only chain-smoking people over fifty-five drink, and the very word evokes the image of stale cigarette smoke bonding to the ice of a curling rink, the sight of the auditorium lights going from bright to dark, and perhaps the sound of Oldsmobiles out in the parking lot turning over their engines. Or another image: Boxing Day, melting grey snow outside, the sound of a hockey game playing too loudly on the TV while a seventy-one-year-old aunt in a fuchsia cardigan adorned with a sprig of holly enters the living room, carrying a tray of Triscuit crackers garnished with Vienna sausages and Kraft pimento cream cheese. "Jesus, get your feet off the table, why don't ya? We're not in the Legion. And pass me my smokes—the ones with the picture of the diseased lung on them." Rye is actually so fantastically out, it can only shortly become fantastically in. Don't forget the ginger ale.

Stubbies

In 1980 I remember that beer bottles suddenly became tall and slender and … *American.* Brand by brand, these new bottle variants snuffed out their predecessor, the "stubbie" beer bottle. At the time, I was happy to see stubbies go, not for aesthetic reasons but because stubbies were an industry standard imposed on Canadians by the Brits. Lord Fruity the beer magnate most likely went to school with Lord Eggy the glass heir, and he owed Lord Eggy a fortune in bridge debts, so to pay off the debts he had to use Lord Eggy's bottles. That's how Canada was run back then.

Most pre-1980 garages have a few dusty stubbies tucked away in them somewhere. In order to get stubbies to photograph, I put an ad in the local community paper and was besieged by calls from fiftysomething men with a nostalgic lilt in their voices. They all wish that stubbies would return, but young people would probably look at a stubbie and say, "What's that thing supposed to hold—molasses?" So I think the stubbie's fate is sealed.

Small Towns

A lot of Canadian literature deals with small town or rural life and/or the immigrant experience. Metropolitan novels with characters who don't discuss the family barn or their country of origin are nearly non-existent. CBC national radio also feeds this trend, with a hefty number of programs ending with a moral along the lines of *I think we all know there's a small town in each of us.*

The reason for this is simple: outside of a handful of largish cities, Canada is a nation of small towns, far more than most other industrialized countries. Many Canadians are only one generation away from the farm. I remember standing in the receiving line at my brother's wedding in Winnipeg. After shaking about the tenth hand missing umpteen digits, I asked one of the Winnipeg relatives what was the deal. The one-word answer? *Threshers.*

Everyone thinks small town are folksy and cute—and mostly they are. But having visited relatives who live in small towns, I acknowledge that you sometimes need to substitute "bizarre" for folksy, and "scary" for cute. I don't always have a soft-focus view of small towns—there are too many of them in my ancestry to be totally comfortable.

... That Judy was bright as a dickens, but she never talked much after the night of the storm when they found Kenny's empty Chevelle in the middle of the canola field.

... Your great-grandfather had the four finest horses in the tri-county region—why, even the prime minister once looked out the window of a passing train and remarked, "Those are the four finest horses I've seen in the surrounding tri-county area!"

... Sure we told the RCMP it was just a stove fire, but everybody in the McGrath family lost their sense of smell that afternoon.

Obviously you need to remember that small towns now, and small towns back then, are different things altogether. Back then, they were prisons of sorts, the only escapes being religious orders or the military, which could be equally as freaky as the town you'd left behind. But now, small towns have almost become lifestyle choices. People who live in northern Manitoba can get a dish and watch MTV Europe or most of the Asian and European stations. Hydro workers in deepest Labrador can trade aluminum futures in real time and then watch streaming video porn so hard-core that it's more a biological treatise than, uh, "casual entertainment."

So these days, if someone's working on the farm, it's likely they really enjoy doing it, as opposed to farm work being a life sentence handed to them at birth. Even still, the stories will undoubtedly go on forever.

… Well, you know, old Clem down by the poultry plant? It was never true he went off to Bermuda that winter like everybody said.

… Your great-great-grandmother really put that little mill town on the map. She could imitate every songbird on the North American continent minus Mexico!

Suburbia

For millions of Canadians, the suburbs are life's main experience, yet their lives are more or less stripped from the history books. The few times suburbanites are ever referred to is with disdain, and usually in conjunction with environmental degradation, the overbuilding of freeways or extinction. How smug! I mean, these are the people who buy the Kraft products and snow tires and watch the TV shows and listen to the music and … pretty much everything else that runs the nation; they're the bulk of Canadian society, yet history books come to a screaming halt at the well-mowed edges of a subdivision, a light-industrial park or a big-box mall.

Why is this? I think maybe it's that Canada's official history was all written and codified by 1976, with the end of the Olympics in Montreal. Everything that came after then is just loose ends and paperwork: having the constitution transferred from Britain to Canada, renaming and redefining some internal boundaries, clearing out the nation's IN-basket.

And so it's very odd indeed to be living in a country where the official version of our history—short as it is—is already "over." What we currently inhabit is apparently an infrastructural residue, good only for housing and servicing consumers. In many senses, in Canada you're not even a citizen—you're a *brand*. "Canada—fresh yummy gun-free water"; "perky red wool Mountie uniforms unsullied by inner city decay." Ugh. And so forth.

Suburban Vancouver and Toronto are popular as movie locations not only because of our enfeebled currency and laxer union laws but because, to much of the world, Canada embodies the way the United States was *supposed* to have turned out. Our suburbs are crack-free, chipper, metric and desirable, and in some senses, Canadian suburbs are the most luscious real estate on earth. When people dream the American dream, they're often dreaming of Canadian suburban mainstays they see in films and on TV: the malls, the community centres, the high school hallways, the garages and attics and basements and main streets. The aspects of Canada's suburbs that make so many historians cringe are the same things that make them such a powerful global dream: it's impossible to imagine a battle taking place outside a donut shop. You can't colonize a mall or betray a dry cleaner or trap animals for fur in an industrial park. The suburbs are a bell jar whose interior is impervious to the goriness and exalted passions of historical outbursts. And that is not a bad thing.

But then, history is going to go on long after you and I are dead. Some day in some way, dams *will* burst. Battles *will* occur. There *will* be blood shed on these cold breezy subdivision cul de sacs amid the ghosts of a billion road hockey games and the ghosts of a thousand minivans washed with dish detergent and sponge mitts. In the darker corners of our souls, we know this to be true—maybe in the year 3066—not for a long time yet, but some day. And until then, much of the Canadian soul will quietly remain both gentle and suburban, waiting for a greater call—like children in a 1970s sci-fi film, waiting to be sucked up into the sky by bright alien lights, the source of which we can never know.

Pages 108/109/112: Chris Gergley, from the "Queen City" Series, 1999–2000
Pages 112/113: Chris Gergley, *"Bridgeport Road" Richmond, British Columbia,* 1995

222's

In Canada you can buy genuine codeine pills. They're available over the counter without a prescription, and they're called 222's … *wooo-ooh!* As well, you can find many terfenadine-type anti-allergy medications, which need a prescription in most other places. Actually, drugs of any sort are much easier to find and/or purchase in Canada, even pot, which, as of 2001, is officially British Columbia's number one industry. So you'd think that with all these drugs floating around, Canada might be an overmedicated, over-woo-woo'ed kind of place. But it's not like everybody wants to go out and have a huge drug binge, and the only thing holding them back is some twisted sense of duty or primness—people just don't want to do all the drugs they can do. Canada is proof of this. So we can say for sure that Canadians have a distinctly altered sense of medication and the body than their nearest social analogs, Americans.

To go further, look at socialized medicine. It arose in Saskatchewan in the early 1960s, and at first it was feared and despised, yet by 1966 Canadians did a permanent 180° shift on the issue—Canadians often opt for a system wherein what's good for all Canadians is good for the individual rather than the other way around. The fiercest opponent of the medical revolution? The insurance industry. Surprise. I remember in the late 1980s and into the 1990s, whenever I met Americans my own age, by the third beer the talk often turned to how they were going to pay their medical bills. And I can't count the number of times younger Americans took a job they didn't really want merely for the medical benefits, which is a waste of a young life. When I mentioned that in Canada we simply went to the doctor "for free," I received glassy-eyed wonderment.

What if they get really really sick?

Then they're cared for.

Don't people abuse it?

Maybe a bit. And it's easy to dip into Canada's medical system and find isolated cases where the system lagged a bit, or where people had to wait for surgery. Usually it's around a U.S. election when this sort of thing is trumpeted about, and mostly in the American media. Surprise again! And people conveniently forget that it's a thousand times easier to locate American medical horror stories than Canadian ones. Just talk to Americans under thirty or U.S. families with an income under $20,000 a year. Brace yourself. Last January in Georgia I had a bad allergic reaction to a local plant. A fifteen-minute hospital visit and a prescription for Allegra (an over-the-counter drug in Canada) cost me $1,100.00.

Usually, the proposed solution to Canada's system is to allow American insurance firms into the country to set up shop. Surprise yet again! But for the large part, Canadians define themselves by the equality and quality of universal medical care, and if the country ever goes to war, it'll quite possibly be about that.

heading north...

Them

It's never felt as different to be a Canadian as opposed to being an American than it does right now. When I was younger, I always thought Canadian stuff was slightly inferior to American stuff—and that being Canadian was being a watered-down version of being American. And then after a while, I began seeing Canadians and Americans as basically equal. And then I stopped thinking about the comparison stuff completely.

But …

But then, sometime in the 1990s, Canada rapidly became *different* from the United States. Not superior and not worse, but undeniably *different*. Half of my friends are American and I have no axe to grind. This is merely observation, and most Canadians I've spoken with feel the same way. Oddly, Canada's process of differentiation is occurring just when it theoretically ought *not* be happening: our country is being hosed over by free trade agreements, it's being inundated by American media from every conceivable outlet, and it's committing cultural suicide as the government totally disengages from the arts (my own personal bugbear). So what's up?

I sometimes wonder if it's the Americans who are becoming different, while Canadians remain basically the same. I've been flying between the two countries a dozen times a year for a decade, and I can certainly say this is a plausible notion. But then I also think that Canadians have changed, too. That damned *distance* that has always kept the country divided and conquered largely vanished, with the help of electronics, around … 1999? Poof! Gone. Nova Scotia, once a far-flung bond-issuing construct utterly disconnected from my life, now feels close to me. I'm feeling kinship with places like Labrador and Manitoba and, well—*the whole country.* I like it.

Other issues obviously come into play when Canadians consider the States. One dark and obvious question that is so scary it's almost heretical is: *Why haven't they taken us over yet?* One supposes they could do it in thirty minutes; they may well even have an ABSORB CANADA button on the White House desk. What prevents them ... military resistance? Right. And somehow, fear of international outrage doesn't seem like a deterrent. So perhaps we need to rephrase an equally heretical question, which is: *Why do they allow us to continue to exist?* It's not as if we've always been best friends. The War of 1812 was a botched U.S. attempt to invade Canada. Canadian Confederation was largely brought about because the Americans, who were furious at the Brits for supporting the Confederates, vowed to take over Britain's North American land holdings in revenge. A cynical answer to this heretical question might be that it's simply cheaper and easier to let Canada take care of itself. Americanizing Canada would only add to the cost of its upkeep and introduce intractable U.S. problems to a place where they currently don't exist. An uninvaded Canada is a cost-effective good buddy—how depressing. But it's not just Canada. The U.S. could take over anybody, really ... New Zealand ... Denmark ... Ghana. But they probably don't do it for exactly the same reasons. We just happen to be next door, so it seems more obvious and more melodramatic.

The moral here is that if we want to remain a country, we have to continue being *Canadian.* This is very good news indeed.

Pages 114/115: Una Knox, *Pacific Border Crossing, Heading North and Heading South,* 2001.

Page 116: A stylized version of the American flag designed by Shi-zhe Yung for Vancouver's adbusters.org

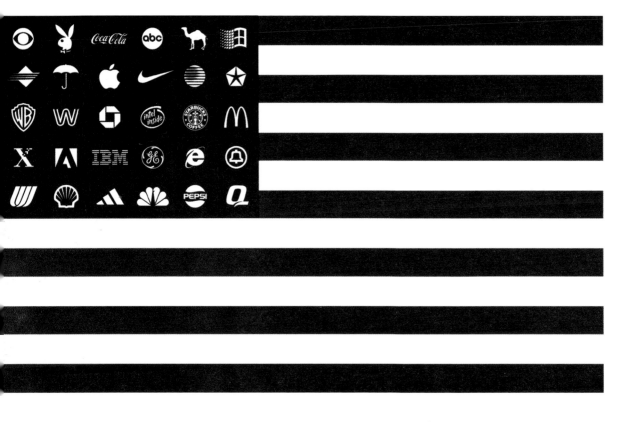

116

CONSULT YOUR DOCTOR OR PHARMACIST
before taking this medication in case of:
– allergy to salicylates, codeine, caffeine;
– asthma;
– kidney disease, stomach problems, peptic ulcers, severe liver disease, or gout;
– severe anemia or blood coagulation defects;
– and if you are taking other medications containing acetaminophen, anticoagulants (blood thinners), medication for diabetes, anti-inflammatory drugs, anticonvulsants, or medication for gout.

PROTECT FROM LIGHT, KEEP BOTTLE TIGHTLY CLOSED.
See inside flaps for additional information.

100 TABLETS
222 ®
N

Acetylsalicylic Acid, Codeine Phosphate, and Caffeine Tablets USP

THIS PREPARATION CONTAINS CODEINE AND SHOULD NOT BE ADMINISTERED TO CHILDREN EXCEPT ON THE ADVICE OF A DOCTOR OR DENTIST

WARNING: This product has the potential to be habit forming.

DIN 00108162

137-539
P/SAVE 214
K1 1234
D100108162
F

100 COMPRIMÉS
222 ®
N

Comprimés d'acide acétylsalicylique, de phosphate de codéine et de caféine, USP

CETTE PRÉPARATION RENFERME DE LA CODÉINE ET NE DOIT PAS ÊTRE ADMINISTRÉE AUX ENFANTS, SAUF SUR L'AVIS D'UN MÉDECIN OU D'UN DENTISTE

ATTENTION : Ce produit peut causer une accoutumance.

DIN 00108162

CONSULTER UN MÉDECIN OU UN PHARMACIEN si l'une des réactions suivantes se manifeste :
– nausées, vomissements, douleur abdominale et constipation.

Comme ce produit renferme de la codéine, il accentue l'effet de l'alcool et de tout médicament qui a un effet sédatif sur le système nerveux. Par exemple :
– les médicaments contre le rhume des foins (antihistaminiques);
– les tranquillisants;
– les sédatifs;
– les stupéfiants;
– les antidépresseurs;
– les barbituriques;
– les relaxants musculaires ou les anesthésiques.

Ce médicament peut provoquer de la somnolence chez certains patients. Il faut redoubler de prudence aux commandes d'un véhicule ou d'une machine ou avant d'effectuer un travail nécessitant de la vigilance. Éviter les boissons alcoolisées.

Trans-Canada Highway

I grew up a few kilometres away from the Trans-Canada Highway, as did a very large number of Canadians. The Trans-Canada Highway goes from Victoria, British Columbia, to St. John's, Newfoundland: 7821 kilometres (4,860 miles). It's a lovely thing when you're young, to be on this road, driving in your parents' car, imagining that if you keep on going you'll end up at the other end of the country. Americans have their interstates, but save for Route 66—which is now technically gone, replaced by a wide number of new highway configurations—none, I think, seizes the national imagination in the same way the Trans-Canada does with Canadians. It's our Big Road. It's our spinal cord. It's our escape hatch. It's the ace up our sleeve. It's a lot of metaphors embodied in one thing.

You need to remember that in 1920, if you owned a car and wanted to drive from Montreal to Toronto, you basically couldn't. No roads. And you couldn't drive to many places in the States or even around your own town. The national railway was a triumph in that it allowed goods and raw materials to be shipped about the country, but personal mobility was still extraordinarily limited. It's a strange fact, but roads are largely a twentieth-century invention—roads as we know them, with two lanes and a passable surface. Up until the 1950s in some parts of Canada, you had to knock on farmers' doors to ask permission to cross their fields or ford their streams. And it wasn't until 1962, when the Trans-Canada was built through Rogers Pass in the Rocky Mountains, that a paved road connected B.C. to the rest of the country.

In 1979 I drove across the country from Vancouver to Toronto with a friend who had to deliver a car to a family member. It seemed like such a good idea at the time—see the majestic wonder that is Canada. I don't know what we were thinking, because there was only one tape in the car (the Allan Parsons Project's *Pyramid*), which was icily ripped out of its plastic casing and unwound across the Trans-Canada Highway just east of Calgary. Before that, I used to wonder why people left long strands of brown cassette tape on the freeway, and that was how I learned the answer: it is the psyche's defence mechanism kicking into place in an effort to stave off distance-induced madness. They're long skinny screams. They are haikus of the void.

23:59:59 December 31, 1999 …

After considering the options for celebrating the countdown to 2000, I decided the best place to do so would be at the biggest, blankest and most nowhere place possible—which, in Vancouver, means the Trans-Canada Highway where it and the hydro lines cut through the outer suburbs. I'd thought the roads would be empty, but they were full of two different groups of people. The first was nineteen-year-old boys who, I guess, couldn't find a date or a party. Their faces were pretty sour. The second was octogenarians, their faces steeled against aging, expressionless, driving into the night. Maybe they couldn't believe they'd made it so far. The big moment took place just before the Gaglardi Way off-ramp, 37 kilometres (23 miles) from the Pacific. The CKWX weathergirl announced, "The last weather broadcast of the twentieth century," and then sniffled. It was sad and blank, and then it was over, and a whole nation lay ahead.

By the time we reached a sign in Manitoba telling us we'd just crossed Canada's geographical centre, we weren't speaking, and even then there were a few days of driving remaining, out of the prairies and into the Canadian Shield's granite and forests, which offered a brief whiff of interest as a change from the prairie flatness. *Wrong.* At least on the prairies we could see the horizon. In western Ontario we could see only the trees, the road and maybe some rocks. It was endless, and after being dumped off in Toronto, it took years for the friendship to rebuild itself. Most Canadians have done this trip or one similar to it, and most have a first-hand experience of the capacity of long journeys to corrode relationships.

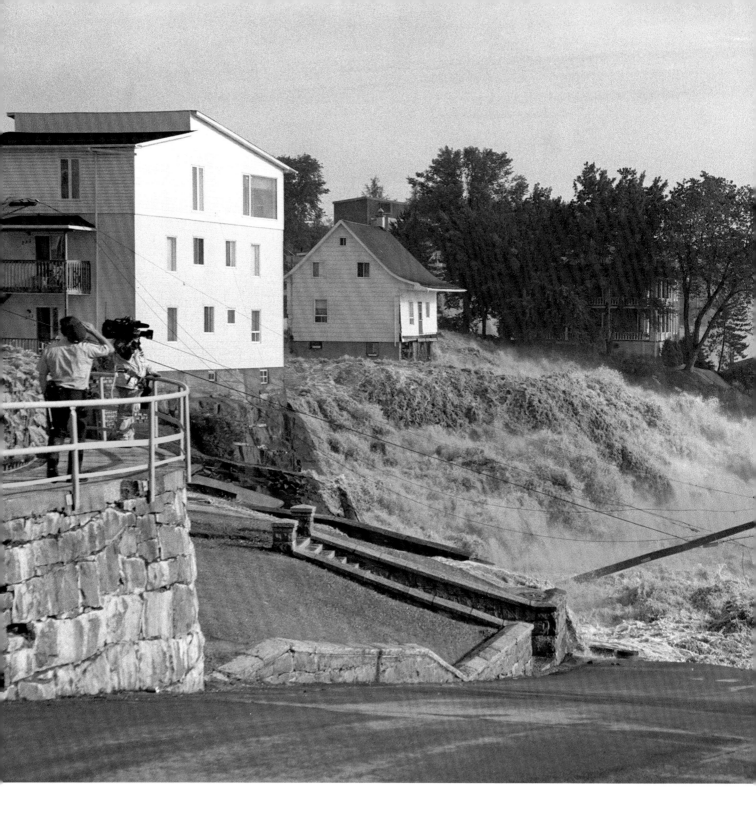

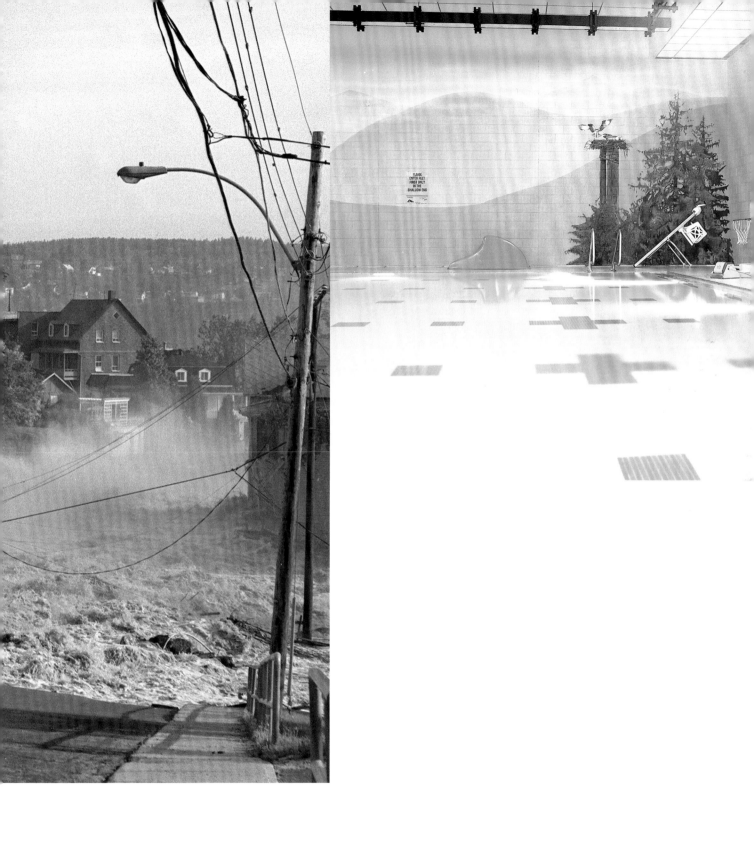

Water

A science-minded friend once told me that while scientists can look at a water molecule and describe it in near infinite detail, there is no way of knowing what, exactly, will happen when you put a trillion quintillion of them together. You can't look at H_2O and predict snow or glaciers or hail or tsunamis, fog, or just about anything else. Which is a way of leading up to the fact that water is utterly unpredictable, and Canada is proof of this. Water defines our nation as much as it defines island nations like England and Japan, or dyked lands such as Holland. Water scours and pummels and licks and crushes and floods and buries Canada, and has done so for billions of years. Dealing with water's eccentricities in all its forms is the hallmark of Canadian history: canoeing in pursuit of pelts, seeking the Northwest Passage, building lakeside trading forts, constructing dams and canals—as well as enduring natural disasters like hail that flattens the crops, floods that obliterate towns, and in 1998, an ice storm of Biblical proportions that coated much of Ontario and Quebec in a glassy thick crust. After the ice storm, the trees made tinkling noises, like wind chimes, just before they snapped in two. Power transmission lines collapsed as though built from uncooked spaghetti. On a lighter note, it's a rare Canadian child who has never thought about putting January snowballs in the freezer to save them for an August afternoon, creating a small frozen time capsule.

Yet again I sit in awe of the early pioneers, of their treks across the land, moving so far and so deeply into an unknown world, excruciatingly slowly while pursuing the promised land— and perhaps topping the crest of a hill and then seeing that promised land off in the distance, only to find a mighty un-European river in need of traversing or a lake so big it looked like a sea. What went through their minds? Water must have seemed cruel and inevitable and ever present, and yet in their hearts the pioneers knew it was the stuff of life. Bargains were made. New relationships between them and the environment were born.

Centuries later, in the 1970s, it seemed as if our relationship with water was finally over— we'd killed it. The Great Lakes were undrinkable. South of the border in Ohio, the rivers caught fire. Oil spills destroyed our precious animals and birds. Northern lakes, filled with a century of

Pages 120/121: In September of 1996, the Chicoutimi River flooded and ran through downtown Chicoutimi, Quebec. The small white house belonged to Mrs. Jeanne d'Arc Lavoie-Genest, and it survived the flooding. For millions of Canadians, she became a moving symbol of the hardy individual surviving against the wilderness.

Page 121: Karin Bubaš, *Nelson Aquatic Centre III*, 2000

lead gunshot, entered a death spiral. In the late 1980s, some friends in Vancouver started a bottled water company. I designed a logo for them, but in my head I thought they were crazy—selling water? We're drowning in it. As it turned out, my friends became multi-millionaires, and I became ever more wary of our toxic relationship with the natural world. I've been up north—I've flown over the glaciers and unmolested ecosystems there, but at the same time I wondered if the planes were spewing polycarbonated crap all over them, destroying even the glaciers. Nothing's free.

All of this negativity aside, Canada remains blessed with more clean pure water than perhaps even the Russian Federation or the United States. And it has dawned on Canadians that one of our national responsibilities—one of the prerequisites of citizenship, even—is to acknowledge this custodial duty. Acid rain seems like it's being fixed—and being fixed well. The Great Lakes are once again nurturing fish. Oil spills seem fewer than they once were. There is hope.

In British Columbia's Fraser River there are sturgeon—Fraser River white sturgeon (*Acipenser transmontanus*)—as primordial a fish as ever has existed—which in the old days grew to the length of three men. The sturgeon is a timid fish, rooting about in the sandbars and shallows for food. Nobody's quite sure where they spawn or much else, for that matter. Now the sturgeon are vanishing, and nobody knows the precise reason why. In essence, sturgeon are these ghostly beings of diminishing numbers, seen ever less frequently in ever-smaller sizes. And in my mind they stand both as a litmus of our dodgy relationship with the wild and as a measure of our own human souls. What happens to the sturgeon is what happens to us. Its dwindling size and numbers reflect some inner dwindling of the Canadian soul.

In Canada, when we speak of water, we're speaking of ourselves. Canadians are known to be unextravagant, and one explanation of this might be that we know that wasted water means a diminished collective soul; polluted waters mean a sickened soul. Water is the basis of our self-identity, and when we dream of canoes and thunderstorms and streams and even snowballs, we're dreaming about our innermost selves.

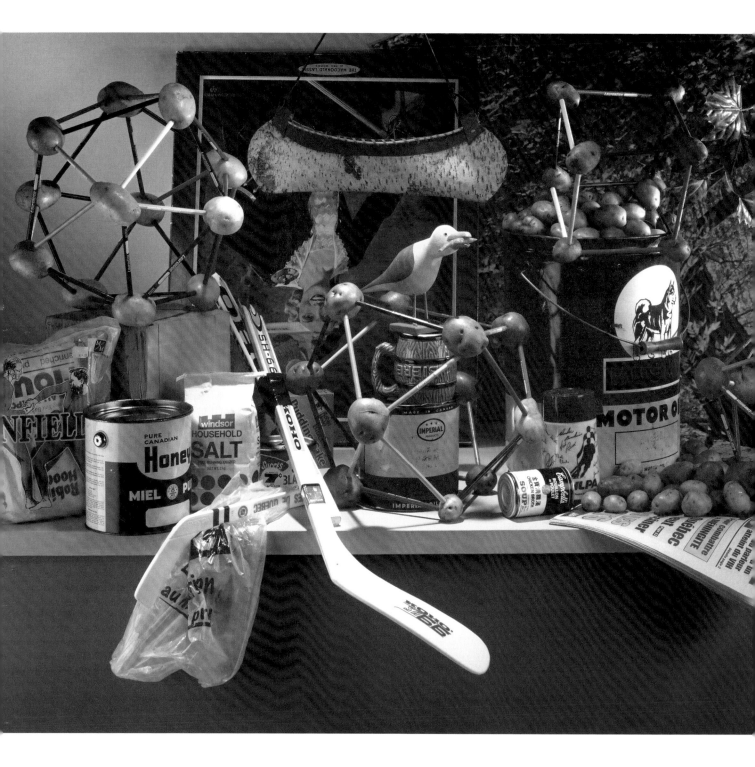

Wild

In the winter of 1998–99, snow was so heavy on Vancouver's local mountains that, come summer, the usual crops of berries didn't grow. This in turn forced a wide variety of animals to move down the mountain slope I live on, not far from the ocean, inside suburbia. As I'm a compulsive bird feeder, my gravel driveway was thick with sunflower seeds and peanuts, the aroma of which must have smelled like a summer barbecue to these poor hungry creatures. One morning a black bear cub ambled down the driveway, paused outside the kitchen window and laid its tongue down onto the gravel to pick up some sunflower seeds. It then waggled its tongue back and forth to shake away the gravel and swallowed the seeds. After climbing up a retaining wall, it had a nice snooze beneath an apple tree. The police, when I phoned, said it was best to do nothing: "But whatever you do, don't feed it—a fed bear is a dead bear." *Did we learn nothing from the Yogi Bear cartoons?* I notified my neighbours about the bear and that was that.

The summer, 1999, was a busy one for wildlife. Eagles nested just up the hill, and hawks made frequent breathtaking darts onto the driveway for a quick feathered snack. The day after the bear cub's visit, I was working in my office at the back of the house, the door open on what was a shiny summer day, when a black blur ran past my door. A few seconds later, two police cars, cherries ablaze, plus the local Channel 6 Newsteam van at the rear, screeched into my driveway, carrying rifles and a video camera.

Cops:	"Where did it go?"
Me:	(to Channel 6 Newsteam) "Turn off your goddamn camera, NOW. This is private property."
Channel 6:	*Mutter mutter mutter …*
Cops:	"Is it in your upper yard?"
Me:	"How should I know?"
Cops:	"Let's look up there, guys."

I was quite glad that Cubsworthy was able to make an escape. Later that afternoon at the seed shop, the lady there showed me a pile of "bear chews"—hanging plastic bird feeders bitten in half by hungry bears. Yay bears!

The next day, the department of conservation trapped and shot a different black bear cub in my parents' back yard, about 8 kilometres (5 miles) east of where I live—the poor thing was also only looking for a few seeds. Some days later, they trapped Cubsworthy at the end of my street, inside a massive steel bear trap painted swimming pool blue. Its mother was halfway up an enormous fir tree, scared witless, and firecrackers were being thrown at her to frighten her and make her fall. She was shot and killed. More than fifty bear kills were made that summer—an indisputable and sad reminder of our proximity to the wild.

That same winter that killed the berry crops, 1998–99, a hiker from Ontario was buried in an avalanche above the middle tower beneath the Grouse Mountain gondola, in plain view from downtown. The avalanche potential was too perilous for rescue parties to retrieve his body, and so for months, Vancouverites stared up at the gondola's path, knowing there was this frozen guy lying dead inside the snow. It was haunting and remains some sort of central myth of the city—just like TransCanada Airlines Flight No. 3, which in 1947 crashed just a short hike away from civilization on Vancouver's suburban North Shore mountains, and remained there undisturbed for fifty years, fifteen skeletons and all, before being accidentally found by a municipal worker in 1997. In the futile search for the craft shortly after its disappearance, dozens of leads were followed, including one from Mrs. E. Van Welter of Mayne Island, who found a photo of a woman in the gut of a salmon she was cleaning and thought it might be one of the flight's female passengers.*

Other wildlife invades Vancouver's inhabited areas with a more casual frequency—coyotes, deer, and skunks and raccoons in droves. Cougars, justifiably wary, stay out on the fringes, and are spotted infrequently. Which is to say that all of these animals are out there, up in the mountains. And they can see the city as clearly as we can see the mountains. What must they make of us? Probably not something flattering

One of my brothers is a champion taxidermist, and he and my father are gonzo hunters. A guns-and-ammo upbringing desensitizes you to the presence of dead animals around the house, all of them filled with polystyrene foam, cotton batting and lifelike glass eyes made in Germany. My brother once lived in a high-rise apartment in very urban North Vancouver. One night he placed a pair of canvasback ducks he was working on outside on his balcony. Around 4:00 A.M., he heard a noise outside his living room, except—except he was on the nineteenth floor. There, in the moonlight, was a Snowy Owl taking off with his ducks.

Look at Canadian money and stamps—you'll see beavers and moose and caribou and loons. Wildlife is a bigger presence in Canada than in most countries. Just ask those sunburned German guys in the airport's departure lounge, headed back to Dusseldorf with whiffs of blood on the hems of their khakis. Animals themselves were essentially the currency of the first few hundred years of European exploration. We now just depict animals on our currency.

On Vancouver's slopes, settlement stops at the 185-metre (600-foot) level, and in summers I used to hike alone up into the forests above that line, walking along old logging roads and hydro easements, trying to make the days pass faster, secretly hoping to find a crashed

*Part of this paragraph was cribbed from *City of Glass*, a book about Vancouver that I wrote in 2000.

airplane or the corpse of a less fortunate hiker. I didn't know then that when bears attack you, they crush your jaws first, so that you can't bite back. I didn't know anything about their behaviour, and I suppose I was quite lucky to avoid being Yogi's lunch.

In Canada, the wilderness is out there—millions of square kilometres of it—and it likes to mess with your mind. It wants to enchant you and kill you and feed you and punish you and love you. It wants to eat you. It seduces you with beauty and calm—that's the bait. You have to be careful with the wilderness, because one false step and you're a pile of blood, hair and bone. Or you've vanished.

At night, when the windows go dark, I sense the wilderness outside the panes, not the city. The wilderness is like the ghost of an old dead friend tapping on the glass, asking you to come out and play—it's familiar but unknowable. How you respond to this call defines you. Are you a camper? Are you a hermit? Would you rather be flying over the wilds inside an Airbus 340? Would you like to be out there breathing in the blackflies and bog vapours? In Canada, you simply cannot ignore the wilderness—and all Canadians have a story of an encounter with it. The encounters are unique, yet they bind us together.

Page 124/125: Canada Picture No. 10, 2001

Page 126/127: Trash can knocked over by black bears out by the chopping block, 1998

Pages 128/129: Roberta Bondar, *Fall colours in the boreal forest, Prince Albert National Park, Saskatchewan*

Page 131: My father, bush pilot Coupland, in Labrador, 1954

Page 132: Roberta Bondar, *Tidal lagoon, Gwai Haanas National Park Reserve, British Columbia*

Page 133: Roberta Bondar, *Fall foliage on the St. Elias Mountains, Kluane National Park and Reserve, Yukon*

Young Country

On July 1, 2002, Canada will be 135, the same age that the United States was in 1911. People who know about U.S. history confirm that the Americans of 1911 had a very sketchy view of themselves as a nation. Civil War amputees still walked the streets, and hatred and resentments of that gothically bloody war still poisoned the common debate. Quebec separatism mercifully pales in comparison. The two world wars had yet to rouse the United States from its isolationism, and the twentieth-century dream apparatus of TV and film had yet to manufacture and reinforce the American mythic canon.

This is a long way of saying that Canada is a staggeringly young country, and we really ought to be easier on ourselves than we are. We beat ourselves up trying to define ourselves when, comparatively, we've generated more myth and identity in our short lifespan than many countries ever did before their 135th birthdays. There's only so much national mythology that can be created in 135 years. Relax.

An added bonus of being young is that you're not, well, *old.* So the future still belongs to you—you can still make your country what you want it to be, and you can protect it from what you *don't* want it to be. Most countries have permanently locked into their myths and identities, and their time for experimenting is over.

Also, when something happens out there in the world, most nations provide their citizens with a default response, thus sparing them the nuisance of reflection, but Canada has no set of default responses for most situations—except, perhaps, for caution.

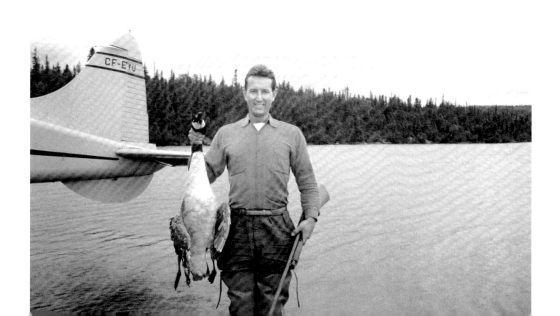

The Yukon

When my father went civilian in 1966, one of the first things he did, once he could, was to buy a twin-engine de Havilland Otter floatplane. I think he did this to re-create what were the happiest days of his life, paying for his medical school tuition by flying bush planes during the summer in the wilds of northern Quebec and Labrador, into areas then still marked UNMAPPED. He ferried the inhabitants of remote outposts to and from hospitals, as well as Canadian and American military and mining engineers invading Labrador, part of what was then a brand-new Canadian province (Newfoundland) only a few years old.

As a young person, trips with Dad in the plane often felt like torture, but with hindsight I can see them as an exotic and charmed way to have spent a part of my youth. When I was around thirteen, my father flew my younger brother and me in the Twin Otter up to the Yukon. First, we overnighted in Whitehorse, a city of diesel fumes, hamburgers, beige dusty roads and people getting really *really* drunk at the local bars. The Klondike fulfills many expectations. The next day we headed off into Kluane *(kloo-awn-ay)* National Park—a place I never even knew existed, but to fly over it was to apprehend God or the next world or something altogether richer than the suburbs of home. Glaciers drape like mink over feldspar ridges like broken backs, and the twenty-four-hour midnight sun somehow burns paler and whiter than the sun in the south—and the horizon seems to come from a bigger planet. To see a wild landscape like this is to crack open your soul and see larger landscapes inside yourself. Or so I believe. Raw nature must be preserved, so that we never forget the grandeur it can inspire.

Anyway, as we landed at a fishing camp on Tincup Lake, my younger brother and I, a bit young for soul-cracking, were intent on panning for gold, having boned up on the subject the week before, becoming experts along the way and doubtlessly destined to tap the mother lode the locals had missed in all of their adult ignorance. We'd barely docked before we hit the nearest stream, our pans verily frisbeeing ahead of us.

Several hours later, we were goldless, but as consolation, we played the ancient game of trying to convince each other that the thin, triangular rocks just found were indeed, *no I swear it, man,* arrowheads.

The next day boredom set in, and Floyd, the boat boy working for the summer as part of a juvenile rehabilitation program, suggested we ride down to the end of the lake to check out a trapper's cabin that had only ever been sighted from the air. The thing about Floyd was that,

well, I wasn't sure if he was a living person or the ghost of a dead boat boy like in a Stephen King novel. Everything about him was white, and he smoked too much and his breath didn't steam the morning air like everybody else's. However, boredom being boredom, we went, with a canoe lying criss-crossed over the twelve-foot aluminum heap powered by an Evinrude 50. We set out around four in the afternoon for the 16-kilometre (10-mile) trip to the end of the lake. Once there, we beached the boat on a gravel bar and paddled downstream. Maybe 3 kilometres (2 miles) down, we came to the cabin, not much to speak of, like the Unabomber's shack after a hundred years of rot.

We parked the canoe and went "inside," quotation marks used because half the roof was gone. At the very least, I expected to find a skeleton wrapped in mummified beaver pelts, because after all, I'd canoed to this place with Floyd the Undead. Instead, we found an old coffee can, the top of a tobacco tin and lots of animal bones in a pile out behind. None of this was very exciting, but at least we'd been the first to visit the cabin in probably fifty years, and I felt what visitors to Shackleton's Antarctic home must feel.

Fine.

Then we portaged up the river's edge maybe ten paces before Floyd the Undead said, "I guess I was wrong, Doug—we can't portage because there's no path."

Moron.

So we ended up wading 3 kilometres (2 miles) upstream in water only a degree above freezing, three steps ahead, two steps back, and it was past midnight when we finally reached the aluminum boat, which ran out of gas after three putt-putts. But it was bright outside and we were young (at least I was—Floyd, being undead, had no age) so we canoed back down the lake, arriving at 4:00 A.M. and expecting a search party in high anxiety. Instead, we found a poker game at the peak of its action.

"Hi guys. Have a good trip down the lake?"

Mutter mutter.

And that is the Yukon. Or a slice of it. Everyone I've ever met from the Yukon is successful: couture designers, actors, builders and private investigators. Something about the place makes people think and act big—that slightly larger horizon makes them look ahead slightly farther. It's a place that delivers the dream.

Page 136: Fiddlehead greens, the pride of New Brunswick
Page 137: Karin Bubaš, *Washing Machine,* from the Florence and George Series, 2000

End: **Zed**

A few days ago, two national newspapers ran simultaneous front-page articles touting the elimination of border crossings between Canada and the United States. They offered photos of long line-ups of cars: *Just think, no more messy and boring waiting in line if we eliminate the border!* They spoke with some politicians: *Some of the politicians we spoke with think it might be a good idea to open the border!* These articles discussed how an open border might be good for business: *More money!* Yet nowhere in these articles did they speak with the average citizen, most likely because the average citizen would puke on the spot if they heard the border was being eliminated.

In the next few days, I polled everybody I came in contact with, and rarely have I found an issue that everybody was so passionately *against*. It really made me wonder if someone (who knows who) phoned up the papers and forcefully suggested that they run some articles on the topic of border removal and see if the skids could be greased for some impending legislation about which the Canadian public will have no say. The same sort of thing has also been happening with mysterious clusters of articles touting the elimination of the Canadian dollar.

Yes, the elimination of the border *à la Europe* might well be a bit better for business (and most likely U.S. business, not Canada's) and ditto for scrapping the Canadian dollar. Is that all we are then, as a country? A *business?* Of course not. But it makes me angry when a solely mercantile vision of Canada is put forth. In a hundred years we'll all be dead, like it or not. Yes, I fear death, and I also fear for the death of Canada. Not in a big noisy way, but in a first-get-rid-of-the-dollar-and-then-get-rid-of-the-border way. What if we become a vast crack-ridden, highway-strangled, ecologically sterilized hunk of nothingness glued onto to the United States? That would be death, even though the maps might still technically say Canada.

At the moment I'm in a 767 en route from Vancouver to Toronto, a flight I call "The Elevator" because it's essentially three hours and fifty-eight minutes inside a comfortable box that has chicken, salmon or lasagna entrées, and bilingual audio programming. I'm in an "A" seat, looking north up the prairies and over, what I'm guesstimating, is southern Saskatchewan.

The fields are like 1970s mural art—rectangles and circles in browns and ochres. Amid the grid are splotches—it's hard to tell whether I'm seeing a lake or the shadow of a cloud—and there are ten thousand popcorn clouds, and maybe as many farmers waking up and looking to the sky and singing, "Oh What a Beautiful Morning!" I briefly develop superpowers and can see radio waves covering the sky like lace: the songs of other eras—the latest dance craze—a documentary about Inuit carvings.

If I were an astronaut looking down, details would vanish, but a larger picture would emerge, a swath of land cloaked in snow and wheat and clean water and pine trees and glaciers which, for much of the world, remains a vision of freedom and of heaven, and rightly so. And from space it would be impossible to miss how northerly a country Canada is, and I could only begin to imagine the lives of the pioneers for whom survival was a far bigger issue than matters of politics or nationhood. Survival has always dominated Canada's history, from the time of the last ice age up until the day you read these words. And it will continue to do so, but survival no longer means portaging through unmapped birch forests that stretch past the horizon, or wintering inside a hut while the wind blows at minus 60°Celsius (-75°F) outside. Survival now means not being absorbed into something else and not being seduced by visions of short-term financial gain.

Canada is not a country that is out to grab more land. People around the world like Canada and Canadians because they know we're not out to colonize them or take their land away from them. Because Canada is not acquisitive this way, the other implication is that Canada is never going to be larger than it already is. Never. So without permanent alertness, Canada can only ever shrink.

An hour later, outside the plane's window, I see Lake Superior. Some clouds are bumping into each other, and it looks like there's going to be rain. This is August, so most of the mosquitoes are gone, the blackflies, too—a lovely time of year to be outside. It's so easy to conjure up images of peace and calm—of summer nights with the neighbourhood kids out on the road

WESTERN

HOMES and LIVING

September 1963 25 cents

Small home with a dramatic entrance • Romantic
restoration • What's happened in home heating •
Planning autumn meals • Fall transplanting tips

playing kick the can or road hockey, hoping not to be called in because everything is just so *perfect*. It's easy to imagine pictures of home and the smell of dinner cooking. It's easy to imagine sitting on deck chairs, sifting through old snapshots: the dog you once had who may well have been your best friend—the seedling outside the bedroom window that grew into the tall strong maple.

But Canada as a country has other images, too—images vanishing with time, but so haunting and potent that to know them is to never forget them—the American ship *Caroline,* set on fire by Canadians in the rebellions of 1837 as it was moored in the Niagara River and sent blazing over the misty edges of Niagara Falls. From the 1700s we have images of bodies of the plague dead weighted with stones and dropped into fissures in the grey-blue ice of the St. Lawrence River. We have images of dusty Depression-era prairies, of clotheslines hung with laundry eaten by locusts, of mountainsides collapsing and swallowing villages.

There is also an image of my father, a finer man it is hard to imagine, in his mid-twenties, flying bush planes in the unmapped wilds of Labrador, camped out at the end of an inlet, seeing a water spout ripping down the fjord, directly at him, a tall twisted tube of white water operating with the force of an atomic bomb. I see my father head from the beach into the nearby forest, grabbing onto the roots and trunk of a pine tree, expecting at any moment to be wrenched away from the earth and be delivered up into the sky, as Canadian a death as can be imagined. Then the waterspout comes suddenly to an end. Peace descends once more onto the water and the land. But for one brief moment there, the sky and earth and water together conspired to deliver the message to my father—and to us all—that we *are* the land, and the land *is* us—we are inseparable—that the land makes us who we are, and continues to do so— and that this knowledge binds us together in a covenant that is as sacred and precious as any written under the eyes of God or otherwise, since the creation of the world.

O Canada.

Page 140: This Ron Thom–designed house was built in the woods of Vancouver's North Shore in 1960, shown here with its original owners in 1963. I bought the house in 1994, and it currently looks quite different. The front door and steps remain, but that's about it. However, the spirit remains intact: optimistic, experimental and curious about tomorrow. It's pure Vancouver, and it's also pure Canada. We're at our best when we try new things; we only seem to goof when we mimic the past or other places. It's our challenge.

Page 144: Karin Bubaš, *Crack Den, Vancouver,* 2001.
A strange way to end things: one final shot from Karin Bubaš's *Crack Den* series (pages 64 and 65.) Here we see a Canadian flag on the floor used as a rug—a sight which on first impression seems negative—when, in fact, the den was bursting with dozens of of other images of Canadian pride. True patriot love.

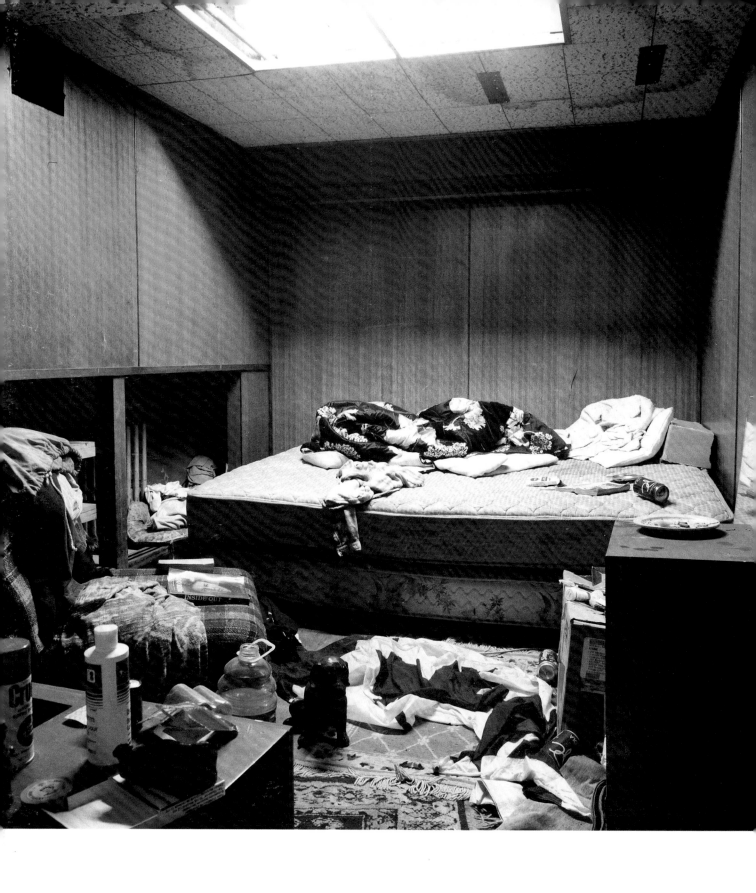